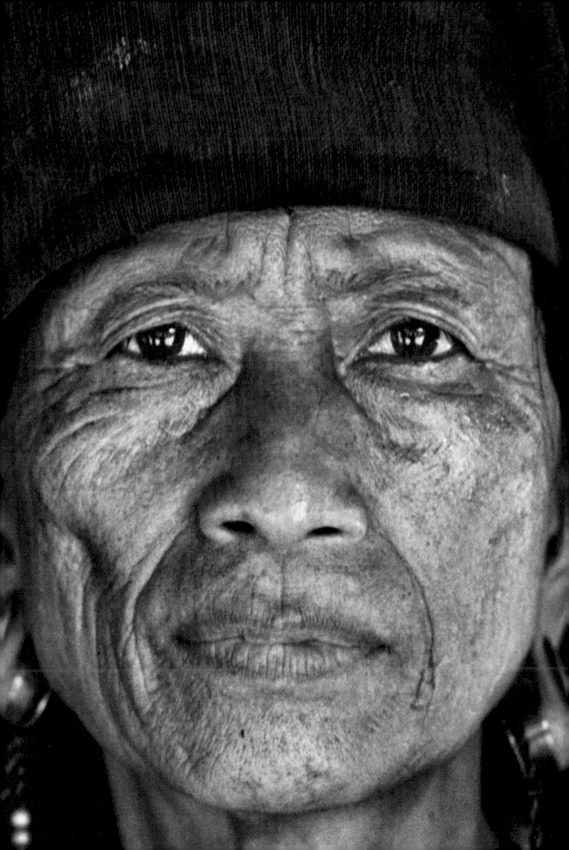

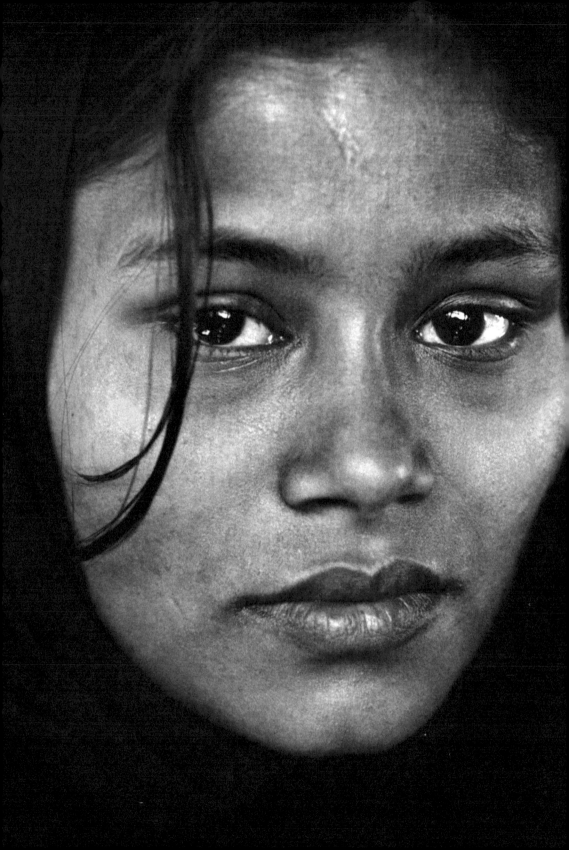

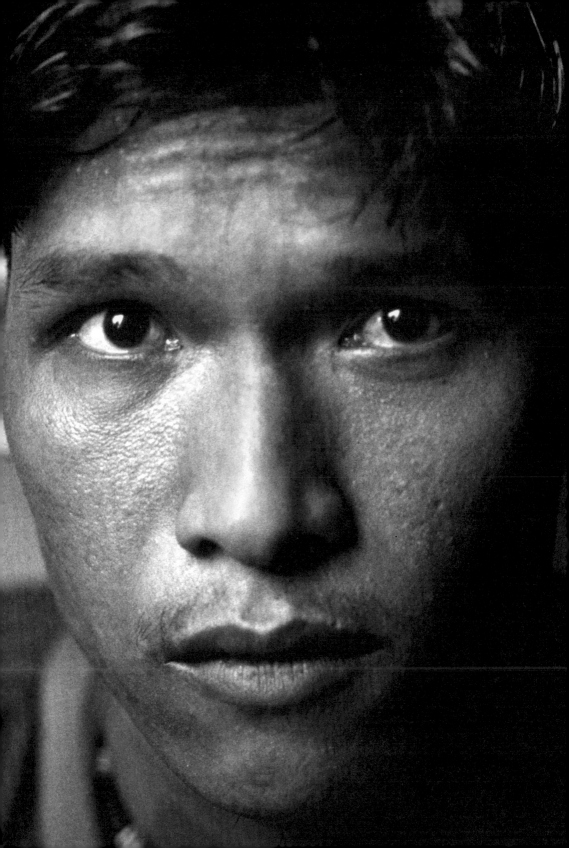

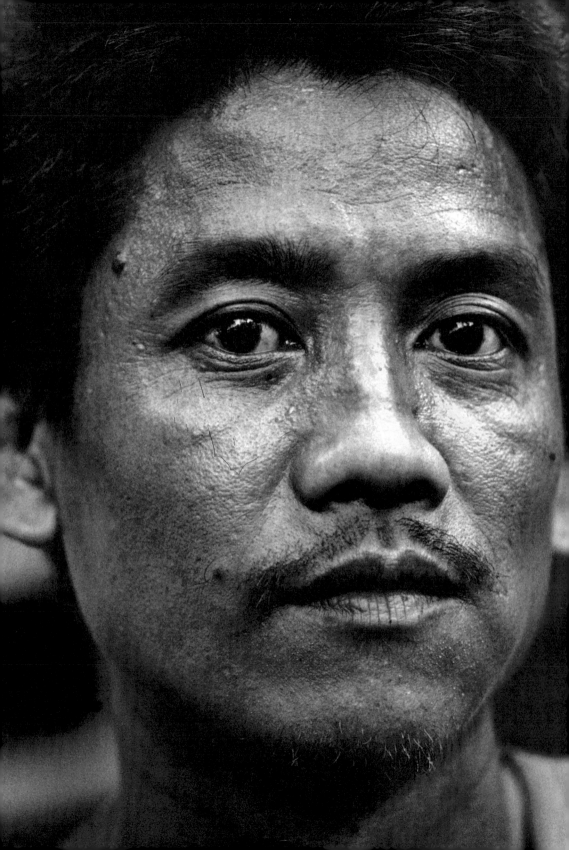

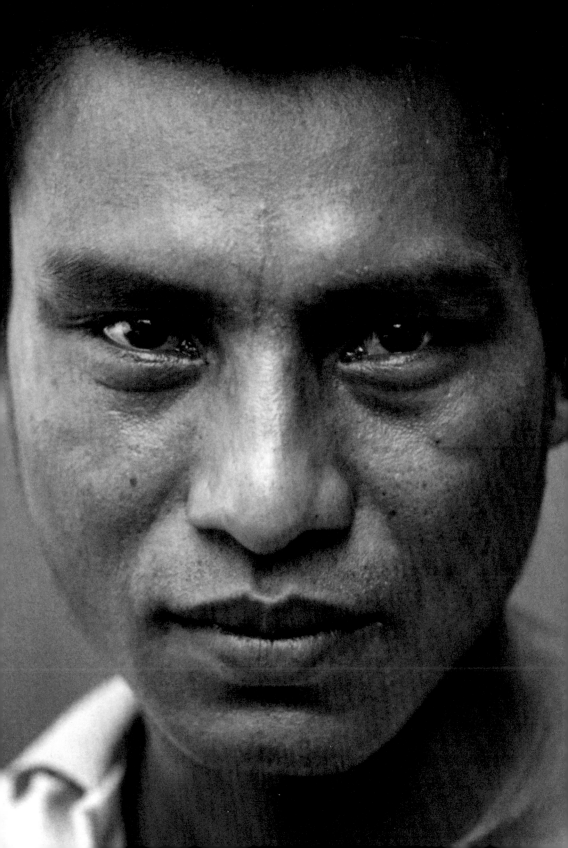

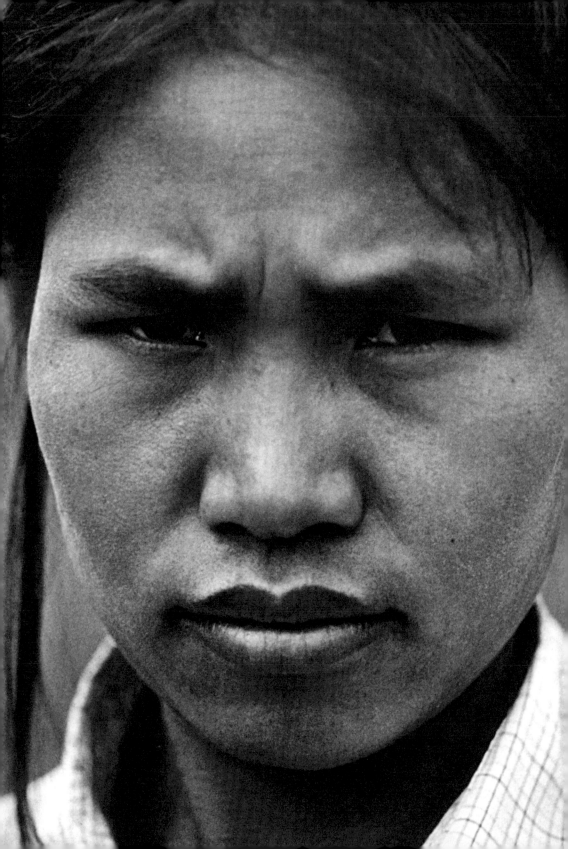

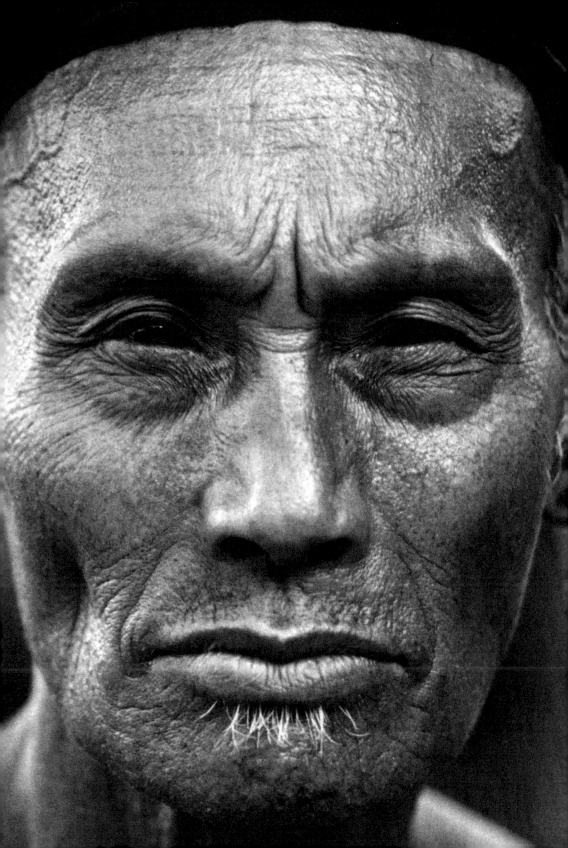

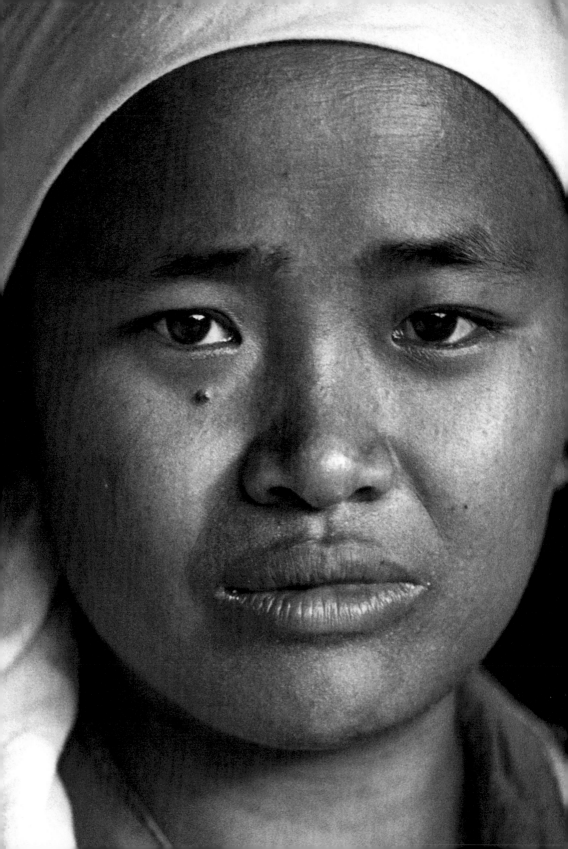

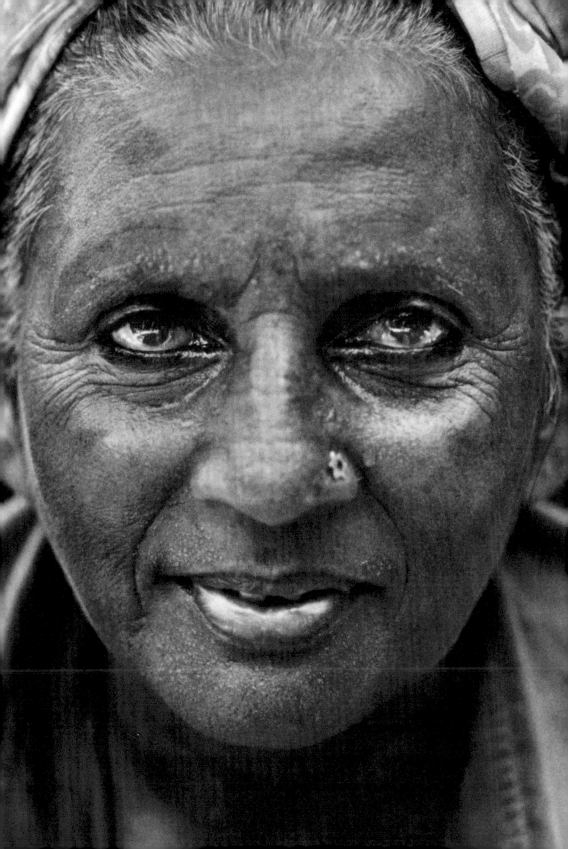

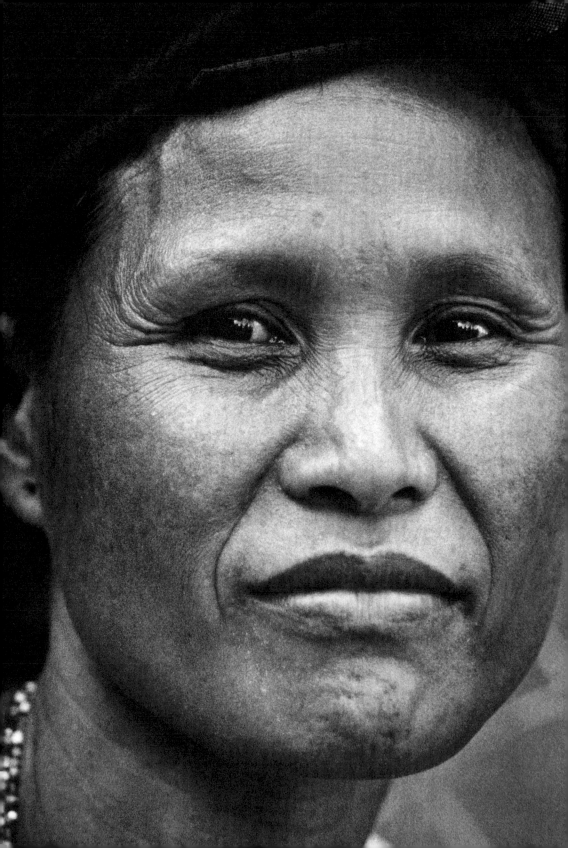

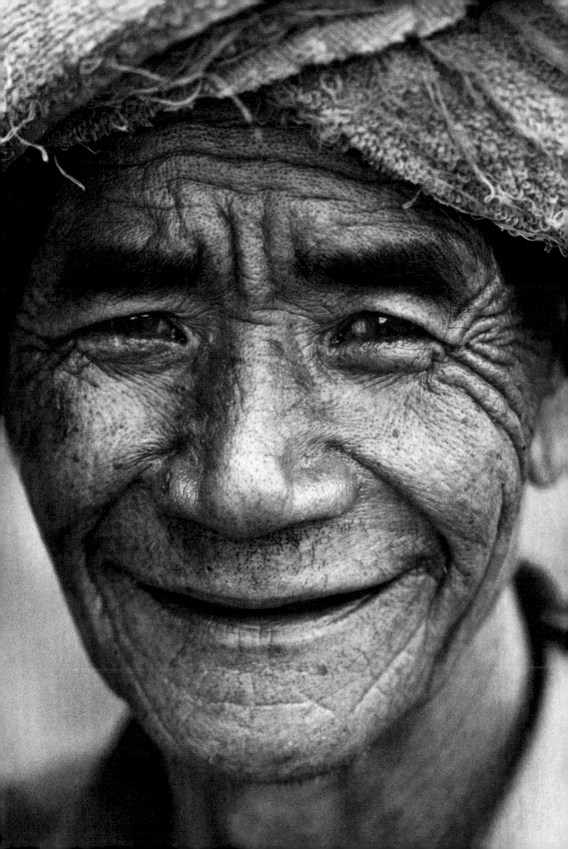

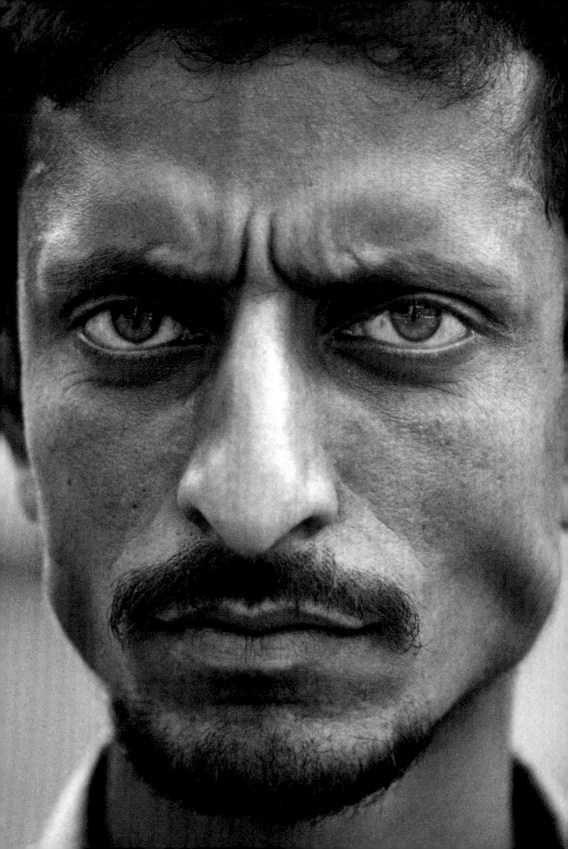

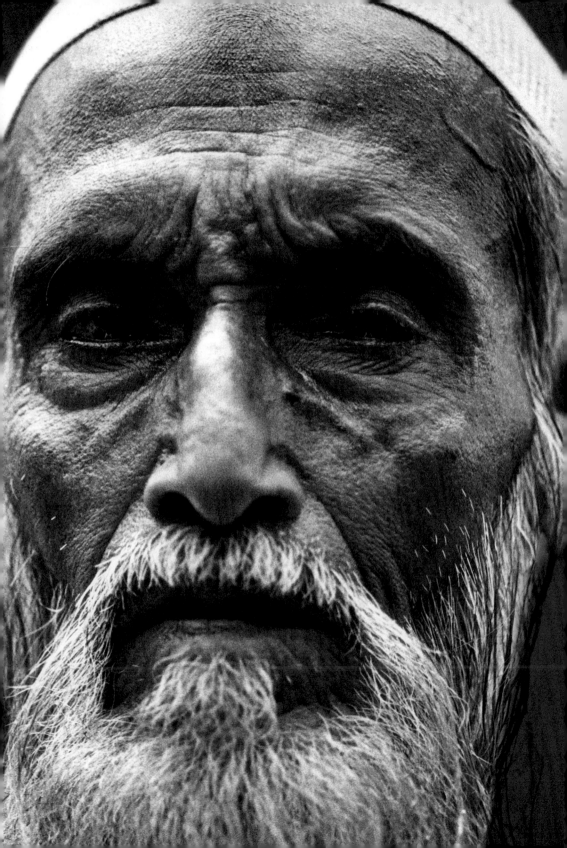

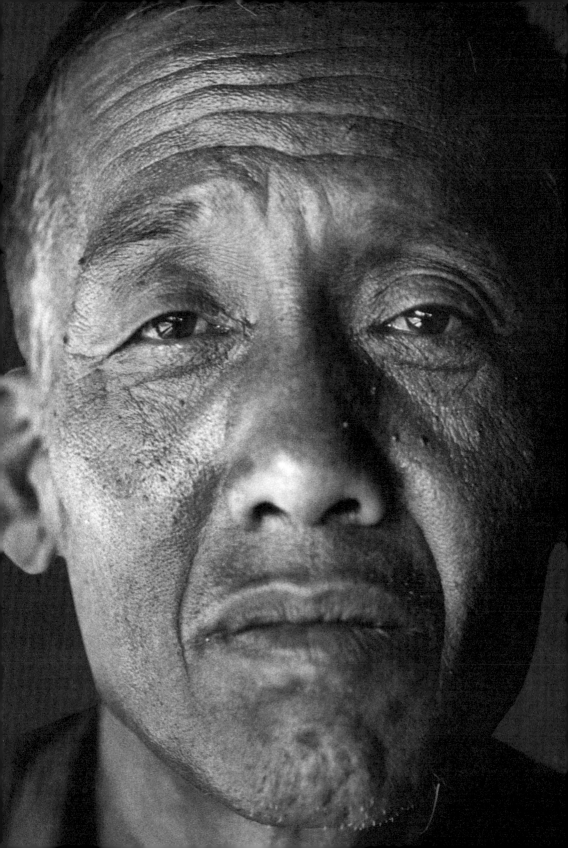

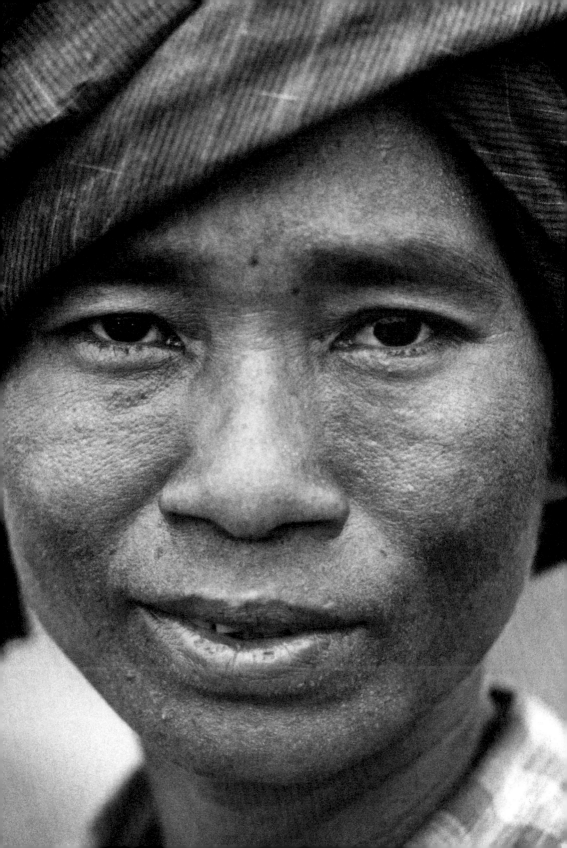

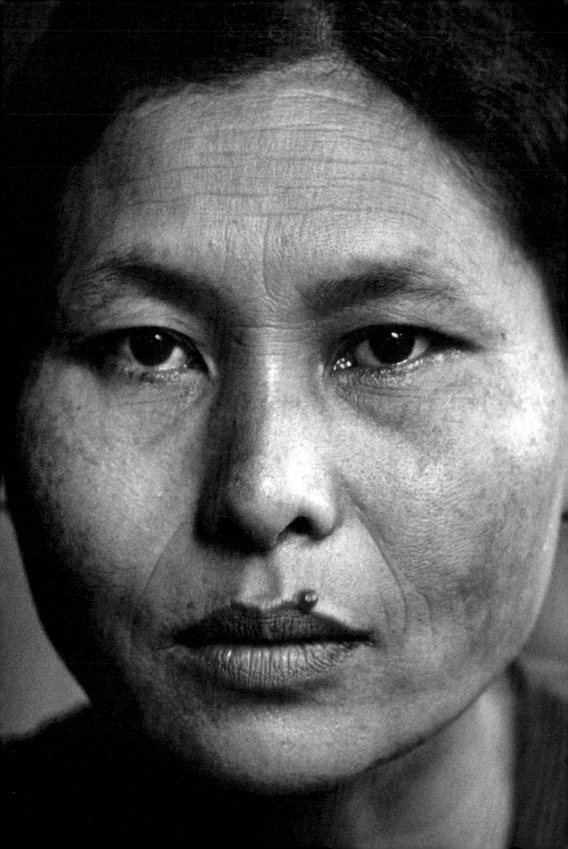

NIC
DUNLOP

BRAVE
NEW
BURMA

DEWI LEWIS PUBLISHING

Brave New Burma by Nic Dunlop

First published in the United Kingdom in 2013 by

Dewi Lewis Publishing
8 Broomfield Road
Heaton Moor
Stockport SK4 4ND, England
www.dewilewispublishing.com

ISBN: 978-1-907893-31-5

Editor: Alexander Linklater

Design: SMITH
Alice Austin, Allon Kaye, Justine Schuster
www.smith-design.com

Print: EBS, Verona, Italy

စည်းကမ်းရှိမှတိုးတက်မည်။

ONLY WHEN THERE IS DISCIPLINE

WILL THERE BE PROGRESS

INTRODUCTION

In early 2012, I sat in a teashop in Rangoon awaiting a bus that would take me to the new capital of Nay Pyi Daw. It was the first time I had been back to Burma since political reform had begun the year before. I was staring at a series of calendar photographs that showed a beaming Aung San Suu Kyi prominently displayed on the wall. No one was paying much attention. It seemed so normal and yet, just two years before, the owners of the teashop would have been arrested for displaying these images. I was having trouble remembering what it was like back then and how fearful people had been.

My introduction to Burma, exactly 20 years before, seemed a distant memory of another world. In 1992, I visited refugee encampments along the Thai-Burma border. Unlike other camps I had been to, there were no barbed wire perimeter fences, no checkpoints, no fleets of Landcruisers belonging to aid agencies. They appeared more like large villages than refugee camps. Set against the mist-covered mountains of the frontier, they looked almost idyllic.

It was only in the clinics of the camps that the reality penetrated this image. There I found victims of Burma's regime. People stared silently through their malarial haze as I took photographs. One mother told me how she and her husband had narrowly escaped marauding Burmese troops who had burnt down their village. She spoke mechanically of their escape, as though it had happened to someone else.

At that time, I understood little of Burma's crisis. I knew the country was ruled by a military dictatorship, that widespread protests had been crushed by the army and that there was an ongoing civil war. I had heard of Aung San Suu Kyi, who had just won the Nobel Peace Prize for her stand against the dictatorship, but that was the extent of my knowledge.

At the border, I listened to the fiery rhetoric of Western activists, feeling out of my depth. They described a situation polarised between the military on the one hand and Aung San Suu Kyi on the other. With the right pressure, I was told, the regime would collapse and Aung San Suu Kyi would take her rightful position as the country's leader.

And this was the Burma we came to know: a brutal military dictatorship and an oppressed people; victims and perpetrators; good and evil. After some time, I realised that we in the West had imposed our own simplistic narrative on Burma's crisis. The reality was far more complex and far more compelling.

When I first went to Rangoon, in 1995, Aung San Suu Kyi had just been released from her first term under house arrest. Tourism and foreign investment were being encouraged and hotels were appearing. The regime had begun to clean up its image in preparation for what it hoped would be a flood of tourists. With Suu Kyi's release, the world's media descended on the city.

At the time, I remember her saying it would be a pity if Burma were to slip from the world's headlines again. Magazines and newspapers can only cover

something if it is accessible or dramatic. What they are unable to portray is a routine reality. A slim corridor of the country was open to outsiders, but large swathes remained off limits. Those journalists who were invited were restricted by their visas, making it difficult to cover Burma as a story. Frustrated by the limitations of the media, I set out to describe the ongoing oppression. I knew this would take time. Over 20 years, I made countless trips inside the country and along its various borders.

Photography, for me, has always been a way to learn first hand. I wanted to get images of a modern dictatorship that would brand themselves on to the imagination. From the frontlines of the civil war to the cities under military control, from Aung San Suu Kyi's house to the labour camps of Shan state, I wanted to show in pictures what a modern dictatorship looked like and what people meant when they talked of oppression. When I started out, I had no idea just how difficult that would be.

It was possible to visit Burma as a tourist and never know the country was controlled by a military dictatorship. Apart from crude propaganda billboards, life appeared normal – and even these signposts looked quaint, like something from a bygone era. Gradually, I began to perceive the impact of the regime on those around me. The people I met were friendly but holding back, unsure if it was safe to talk to a foreigner, fearful of spies.

References to politics were oblique and momentary. When I did catch glimpses of the regime at work, they were usually fleeting: the outline of a pair of handcuffs in a man's longyi (sarong), a member of Military Intelligence filming the crowd outside Aung San Suu Kyi's home, an unobtrusive arrest on a street corner. The dictatorship was so deeply entrenched, I realised, that there was no need for soldiers on the streets. This left me in a quandary; how do you photograph a paranoid conversation on a Rangoon street corner?

By the mid-1990s, Aung San Suu Kyi had become the face of Burma's quest
for human and democratic rights. Most photographs showed a glamorous
woman smiling off the years of isolation. With the portrait I took, I wanted
a photograph that would "say" something about what she represented and
the difficulties she faced – to complicate her image with psychological reality.
To my surprise, I found it being brandished by activists in protests around
the world. Whatever my pretentions, Suu Kyi's face had become a global icon.

Aung San Suu Kyi was one of the few who could be photographed and identified.
But with ordinary people, and because of the fear that governed so much of life
in Burma, it was difficult to achieve a degree of intimacy without putting them
in danger. The military was clearly feared and despised, but it was not clear
what underpinned the power of the generals.

For ordinary people, the dominance of the military was not merely
the control of a totalitarian state imposed on a suffering people; the reality

of life had long been a mixture of coercion and collusion. The regime's hold
was also a response to internal conflicts dating back to the Second World
War and, before that, to decades of British occupation.

Burma is one of the most ethnically diverse societies in the world, with more
than 130 distinct races. It is also home to the world's longest-running civil war,
with a patchwork of ethnic insurgents battling the regime. This conflict began
long before the military took over. But for the outside world, the civil war was less
compelling than the straightforward stand-off between Suu Kyi and the generals.
In fact, the struggle for basic rights inside the country was inseparable from the
civil war which ran central to Burma's crisis; what linked them was the military.
And support for Suu Kyi, I discovered, is not universal. Some insurgents
I met pointed out that her father, General Aung San – an ethnic Burman –
was founder of the army they had spent decades fighting.

Burma has now entered a new chapter in its history. After years of political

stagnation and isolation, a nominally civilian government has begun a programme of reform. But the changes that have begun to take place in Burma are not irreversible. Military rule could still be re-imposed and, as long as there is ethnic tension and violence, the reform process remains tenuous. Although much has changed inside the country, much remains the same.

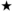

Photography is, in large part, about projection. We see the things we want to see, irrespective of more complex realities. In my portrait of Aung San Suu Kyi, she can be seen as strong, courageous and principled. That was my intention. She has been compared to Nelson Mandela, Martin Luther King and Gandhi, whose philosophy of nonviolence she has espoused. But photography is an inherently ambivalent medium. Her portrait may also reflect other characteristics: stubbornness and self-righteousness, for example.

In this book I set out to describe life under a modern dictatorship: what it looks like and how it affects the lives of ordinary people. The "Scorched Earth" chapter deals with the civil war and the persecution of ethnic minorities; "The Invisible Dictatorship" takes the reader on a journey into life under a repressive regime; and "The Burmese Gulag" provides a glimpse into the world of political prisoners, torture and forced labour. But perhaps the most ambiguous portrayal is "The Enemy Within", a profile of the Burmese armed forces – the Tatmadaw – which has dominated life since 1962. The monolithic image we may have of a united and brutal force breaks down to reveal not monsters, but ordinary men and boys: the rank and file of the army. And then there are those who have fled. "Freedom from Fear" describes the lives of Burmese men and women who have sought a better life in neighbouring countries – often to be confronted with other perils. The final chapter, "Brave New Burma", describes the situation as Burma gradually moves away from direct military rule.

Looking back over my photographs, I realise I had long been obsessed with images that contained a narrative, preoccupied with what they might "say". When I took portraits of individual people, however, the process was almost unconscious: a simple response to those around me. At the time, I held little store by these. Now, it is less the pictures of forced labour or the military that I turn to, than the faces of ordinary people: from the streets of Rangoon to the fields of upper Burma, from the refugee camps in Bangladesh to insurgent armies in the jungles.

For me, these portraits represent the antithesis of the national conformity that the regime has tried to impose. They refuse categorisation and, if they tell any story at all, it is simply that of Burma's extraordinary diversity.

The portrayal of Burma's crisis as a stand-off between Aung San Suu Kyi and the generals is not incorrect, just simplistic. It is a starting point; one that, with a closer look, opens up into a more nuanced, more difficult, but also, perhaps, more rewarding picture.

တပ်နှင့်ပြည်သူ
လက်တွဲကူ
ပြည်ထောင်စုဖြိုခဲ့သူ
မှန်သမျှ ချေမှုန်းကြ။

TATMADAW AND THE

PEOPLE CO-OPERATE

AND CRUSH ALL THOSE

HARMING THE UNION

SCORCHED
EARTH

*Citizens of the Frontier Areas shall enjoy rights and privileges
which are regarded as fundamental in democratic countries.*
 Panglong Agreement, 1947

Since 1948, the Burmese army has been at war with its own people. Ethnic groups have long been denied some of their most fundamental rights as the army pursues insurgent armies. Villagers are routinely press-ganged into carrying supplies to the front, where they are beaten or killed if they collapse. Women are often gang-raped and villagers used as human mine-sweepers. People are herded around the countryside in mass resettlement programmes.

The patchwork of ethnicities that makes up Burma's population – Karen, Burman, Chin, Kachin, Pao-O, Palaung, Karenni, Rakhine, Shan, Mon and Naga – forms a network of tensions, not just with the regime, but at times between each other. This continuing antagonism ensures they are unable to mount a united front against Burma's armed forces, the Tatmadaw.

The junta has attempted to assimilate ethnic groups by force. When the military took power in 1962, General Ne Win introduced the idea of a Burmese family of races in which everyone "shared one blood and historic origin" – Burman. Ethnic languages were replaced by Burmese in schools and place names were changed. Mosques, churches and sites of historical and cultural significance to ethnic groups have been razed or taken over by the military. This "Burmanisation" of ethnic areas continues to this day.

The military's scorched earth policies in these areas have created more than half a million refugees. The army employs a counter-insurgency tactic known as the "four cuts" policy. This policy aims to cut off insurgents from four resources: information, funds, recruits and supplies. Reminiscent of the British pacification campaigns in the late 19th century, it bears a striking resemblance to the disastrous "strategic hamlets" programme deployed during the Vietnam War: villagers are forced to move to areas under Burmese army control with no compensation for their loss of livelihood. Here, they live in the shadow of their overlords, who behave like an army of occupation.

Rather than live under Burmese army control, many villagers have abandoned their homes to live in the forest. Others have fled to refugee camps in Thailand and elsewhere. The areas outside the relocation sites are treated by the Tatmadaw as "free fire zones", where everything is a legitimate target. The Tatmadaw routinely co-opts villagers into government militias, fragmenting and dividing communities as part of a strategy to subdue the population and weaken insurgent forces. Although the junta has signed ceasefire agreements with armed ethnic groups, several continue their campaign of resistance against the junta.

When the army moves into an area where insurgents operate, a letter is sent to the local headman. The letter is an order for the villagers to leave the area. With it is a chilli pepper, a bullet and a piece of charcoal. The chilli is to warn villagers that the soldiers will kill their livestock and eat it, the bullet a threat to shoot anyone who stays and the charcoal means they will burn the village to the ground.

Mu Nang

Mu Nang's earliest memories were of running. As a child, she thought it was normal to be constantly on the move. Originally from the Padaung tribe in Karenni state, she fled to Thailand in 1989. "My house was burnt down four times in four years," she told me. "We moved from one place to another; life was never stable."

Every move was preceded by a warning. Karenni soldiers would arrive, usually in the middle of the night, to alert Mu Nang's family to an impending attack by the Burmese. Along with other families, Mu Nang and her brothers would grab a few posessions and make for the forest. There they would wait in hiding with their parents who tried desperately to keep the younger children quiet in case their cries would betray them to the Burmese. She could hear the fighting as fires from burning houses lit up the night sky.

It was only when she arrived in Thailand that Mu Nang realised that war was not a normal state of affairs. All the years of running angered her. "Why do we have to suffer like this?" she thought. "I became angry with everything, especially the military government, because I know that it happened in many other villages and not just ours. In Thailand, you see that people are at peace."

It was there that she lived in one of the numerous refugee camps that straddle the border between Thailand and Burma. The first group of refugees to cross into Thailand in 1984 numbered no more than 10,000. By 2005, there were more than 150,000 refugees in camps consolidated along the Thai frontier. Many more were hiding in the forests in outlying areas of the country.

But in the no-man's land of Thai refugee camps, different problems arose. Although they are relatively safe, the people there remain largely dependent on outside aid. And this dependency erodes a sense of self worth, robbing people of their dignity. "If you stay in the camps, you feel very isolated," Mu Nang explained, "because you're just waiting for the aid organisations to come and feed you. Nobody wants to be in this situation. You want to work and earn by yourself, you want to stand on your own two feet." Because of the cramped conditions and the listlessness of refugee life, alcoholism and domestic violence are serious problems. Generations have grown up not knowing what a rice field looks like. "When it goes on for so long, you feel that you no longer have your own identity."

Ethnic Conflict

In 1947, the Panglong Agreement was signed between General Aung San and leaders from the Shan, Kachin and Chin ethnic minorities. It was seen as an important first step towards unity in a deeply divided country. The agreement stated that all the peoples of these ethnic areas were to "enjoy rights and privileges which are regarded as fundamental in democratic countries". The Rangoon government also accepted "full autonomy in internal administration" for these areas, reserving the right to secede after ten years. Shortly after the agreement was reached, Aung San was assassinated and fighting broke out. The agreement

was never honoured. A strong Burmese army was built up, which gradually pushed these insurgencies to outlying areas.

A key function of the junta's propaganda has been to exploit widespread fear of the country breaking apart. Among the Burmese living in cities, there is little knowledge of the conflicts. The army deploys a divide-and-rule policy similar to the one the British once used to pacify the country. The people have been deliberately kept ignorant of the true nature of the war. To the outside world, the insurgencies have appeared separate to the issue of totalitarian repression: in fact, they are inseparable. The civil war has been central to the regime's justifications for its hold on power. Shortly after her release from house arrest in 2011, Aung San Suu Kyi called for "a second Panglong agreement". It barely got a mention in the international press.

With further offensives against various ethnic armies such as the Karen, refugee camps on the border were consolidated in 1997 and the camp populations more tightly controlled. The Thai authorities banned refugees from going outside camps, but many need to seek work to supplement the supplies they are given. Summer can bring a lack of clean water. In order to clean the water, many refugees sneak out to get wood to supplement their charcoal rations. If they travel outside, they risk arrest and imprisonment. It's either that, or face the risk of water-borne disease. In one incident, a woman told me how she was shot at by Thai soldiers when she tried to sneak out.

Far from being passive victims of the civil war, refugees can be highly organised. In Mae La camp, for example, the Karen Women's Organisation comprises over a hundred staff, dedicated to improving the lives of women in the camp. They run nursery schools, an orphanage, teach literacy, conduct training programmes and provide safe houses for women seeking shelter from domestic abuse. Yet, with little hope of a future, some young men join ethnic armies to fight the Burmese.

Ethnic armies have been battling the Burmese military for more than 60 years – most of them for autonomy and a federal system of government. Although ceasefires have recently been agreed, with many ethnic armies and major operations halted, the situation remains tense and reports of human rights violations continue to emerge. In the north of the country, a 17-year-old ceasefire broke down between the Burmese and the Kachin Independence army. In the West, sectarian violence between the Buddhist Rakhine and the Muslim Rohingya erupted, displacing tens of thousands.

THE SHAN

In the late 1990s, I sat on a grassy ridge watching shells land on the other side of the valley. All along the crests of the hills, which marked the Thai frontier with Burma, I could make out trenches and earthworks, occasionally interrupted by forest. These encampments belonged to the Shan State Army who were under assault by the Burmese and their allies, the Wa. The rumble of battle echoed across the hills as small mushroom clouds spiralled upward in the distance.

The bamboo fences that circled the tops of the hill encampments reminded me of Celtic fort illustrations from school books. In abandoned villages below, Thai soldiers lay in the shade watching the battle, their Scorpion tanks parked behind rice mills.

Burma is the second-largest producer of heroin in the world, next only to Afghanistan. It is also home to one of the largest drug cartels in southeast Asia, the United Wa State Army. Boasting some 20,000 fighters, the Wa have allied themselves with the Burmese military and moved on from opium production to become the largest producers of methamphetamines in the region. The junta is believed to be heavily involved in this lucrative trade. To add to this soup of warring factions, the Wa often fight against opponents of the junta.

Later I visited the Shan State Army's headquarters of Loi Tai Leng, which straddles a ridge along Thailand's northern border with Burma. Here, in the infamous "Golden Triangle", the SSA had been fighting

The Shan State Army headquarters on the Thai border.

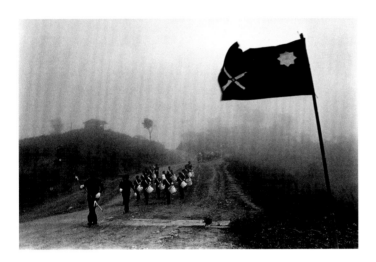

for an independent homeland for more than a decade. The SSA denied any involvement in the drug trade.

Amid rolling mountains that spread out as far as I could see, it was easy to forget that Loi Tai Leng was a military headquarters. It boasted four shops that served noodles and had recently acquired 24-hour electricity. In the early afternoon, the crisp mountain air was pierced by the sound of rowdy youngsters spilling out of schools as they headed home. On either side of the track were houses with small gardens separated by neatly trimmed hedges. These were the homes of SSA commanders and their families.

Hardly any of the people in Loi Tai Leng had ever known peace: war and insecurity were their reality. On the last day of my visit, I visited a frontline position to talk with the Shan soldiers there.

Gong Pa Kha outpost had breathtaking views of the surrounding landscape, with the United Wa State Army positions perched below. The soldiers told

me how, in 2005, the Wa attacked this position in a battle that lasted over a month. Wave upon wave of Wa fighters, said to be high on amphetamines, scrambled up the mountain slope toward the Shan in their heavily fortified bunkers. Many were killed.

We arrived as the sun was going down. One of my escorts wandered over to a nearby trench where he could get a signal for his Thai mobile phone. I joined a group of soldiers huddled around a fire in a hut. Sai Pang, the commander, had been in the trenches throughout the assault. He told me why he joined the SSA.

Burmese troops had arrived in his village and ordered the people to move closer to town. "They said if we didn't move, they'd kill us." Some decided to ignore the order and stay. He hid in the forest until the deadline had passed. When Sai Pang returned, his village had been burnt to the ground. Several corpses lay nearby. "The Burmese had shot them all over their bodies," he said, staring into the flames. "They took umbrellas and forced them up the women's vaginas."

Did he think the Shan and the Burmese could ever live in peace?

"If they – the Burmese army and those who support them – stop using these tactics, then they can."

Another, younger soldier disagreed. "The Burmese just want to kill; it's ethnic cleansing," he said. Other soldiers nodded in agreement. "There is no way for them to stop it. It's in their nature. They want to get rid of all the ethnic groups and only have their own," he said. "As long as there is ethnic cleansing, there can be no democracy." He had spent time in Mandalay city and had nothing good to say of the Burmese. "Burmese people I met talk nicely, but in their hearts, there is nothing good there. I don't trust any Burmese."

But what about Suu Kyi?

"I don't believe in Aung San Suu Kyi. She's good for the Burmese people, perhaps, but not for the Shan." Suu Kyi was the daughter of the founder of the army the Shan had spent decades fighting. From his point of view, on the frontline, the Burmese are an army of occupation. There could be no compromise.

"They invaded our state," he said.

THE ROHINGYA

On the other side of the country to the Shan, in Rakhine state, live some of the most persecuted people in the world. Known as Rohingya, many are descendants of Arab, Moorish and Bengali traders who settled in Burma centuries ago and are still viewed as aliens by the Burmese.

Shortly after the military took power in 1962, it announced that the Chinese and Indians, including the Muslims of Rahkine state, were illegal immigrants who had settled in Burma during British rule. The junta took measures to drive them out, stripping them of citizenship. Discrimination was institutionalised and limitations imposed on their access to education, employment, travel and public services.

Fifteen years later, the junta launched a nationwide campaign to register citizens and prosecute illegal immigrants. The campaign began in Rakhine state and mass arrests, accompanied by violence and brute force, including the burning of many mosques, triggered an exodus of 200,000 of the Rohingya into Bangladesh. Ten thousand died of malnutrition and illness after food rations were cut to compel them to leave. The junta justified the exercise as a fortification against Muslim extremist insurgents in Rakhine state. The military build-up was accompanied by compulsory labour, confiscation of land and property, forced relocation, widespread rape, torture and summary executions. Mosques were destroyed, religious activities banned and Muslim leaders harassed. By 2007, there were more than 36,000 refugees languishing in camps in Bangladesh.

On several occasions, the Rohingya have been forced back against their will. As one refugee said: "we are like a football: kicked this way and that."

Bangladesh, already burdened with a chronic population problem, is not a signatory to the 1951 UN refugee convention and views these desperate people as illegal immigrants. With nowhere to go and their ethnicity denied by Bangladesh, the Rohingya represent the international community's failure to protect refugees. Their camps are tightly controlled by the Bangladeshi authorities and few aid organisations operate there. Abuse at the hands of the authorities is commonplace. They are trapped in conditions that are among the worst of any refugees in the world.

In 2007, I visited a makeshift camp in Bangladesh where 10,000 people were confined to overcrowded, tight spaces on the side of the road with insufficient water and inadequate shelter. When the rains came, Médecins Sans Frontières, the only aid organisation working with the refugees at the time, gave them plastic sheets, which many sold for food. Their fetid shacks were squeezed in between the road to Teknaf and the Naf River, which flooded the camp during the rains. Water-borne parasites and malnutrition were rife, causing outbreaks of disease. In stark contrast to refugees in Thailand, they received virtually no outside assistance.

I watched as the Bangladeshi authorities ordered the residents of the camp to dismantle their shacks that lined the road. It was part of a nationwide programme to put an end to encroachment in this overpopulated country. I wandered through the camp taking photographs. People were wailing as their homes were taken to pieces. At one point a woman came up to me, tears streaming down her face. "We have been suffering in Bangladesh for a long time," she said. "Nobody will help us – only take photos! It's no use to us! We don't want to stay in Bangladesh or go back to Burma; we'd prefer to die in the Naf River!"

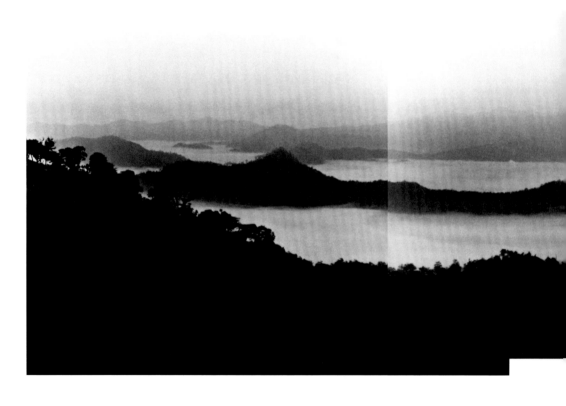

Dawn in Shan state. Traditionally, minority groups
such as the Shan, Kachin and Chin have lived in
outlying mountainous areas. The Burman majority
live in the lowlands.

OVERLEAF Soldiers of the Kachin Independence
Army on the frontline, northern Burma.

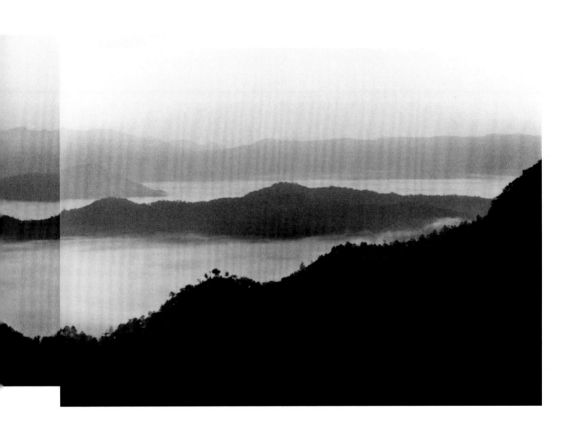

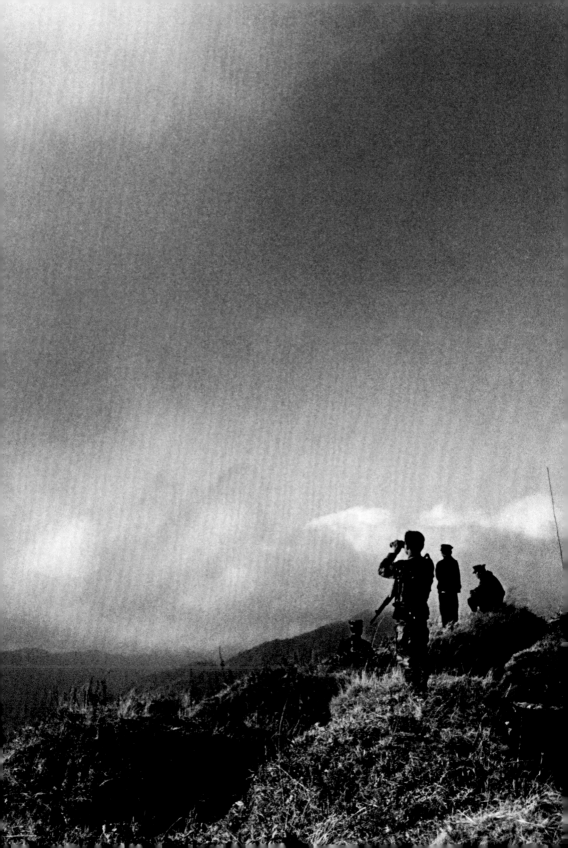

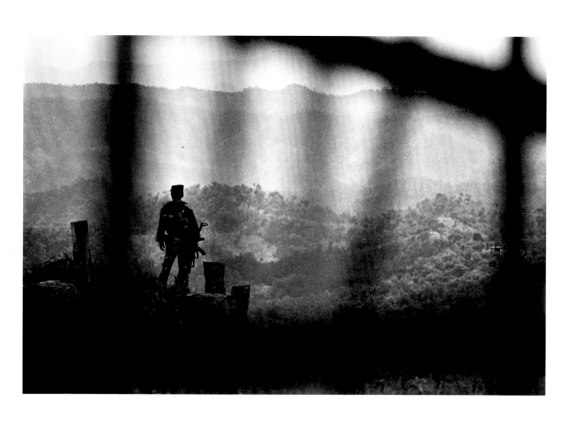

A soldier of the Shan State Army. The Shan have been
fighting for an independent homeland for decades.

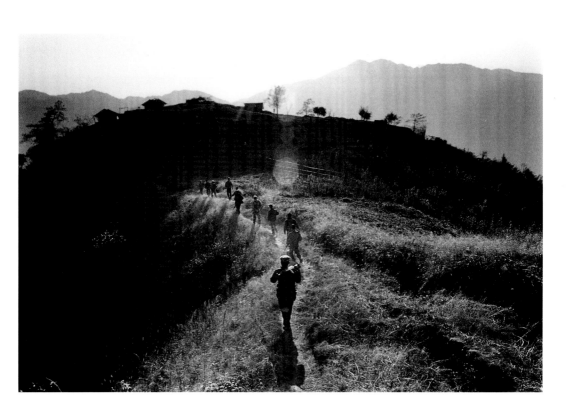

Troops of the Kachin Independence Army on a frontline,
7,500 feet above sea level. In Kachin state and other
outlying areas, the Tatmadaw continue to abuse civilians
through forced labour, rape and murder.

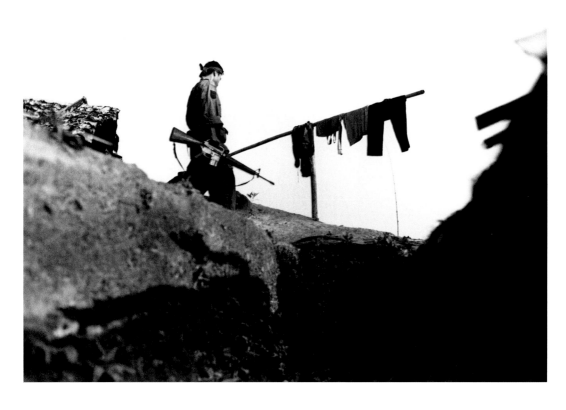

Student army, Karenni state. The All Burma Students'
Democratic Front was formed after the 1988 uprising,
when protests were crushed by the Burmese military.
Thousands of students fled to the Thai border and
organised armed-resistance with the support of
ethnic insurgents.

Soldiers of the Karenni National Progressive Party
move through no-man's land. Apart from a brief
period in the 1990s, the war between the Karenni
and the Burmese army has continued without
interruption since 1948.

OVERLEAF The Karenni frontline in eastern Burma.

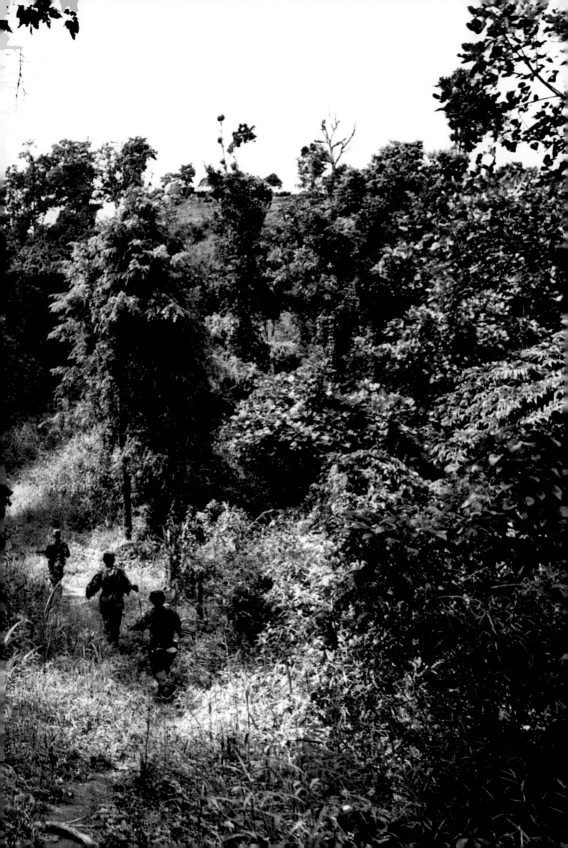

The Salween River marks the frontier between Burma
(left) and Thailand (right).

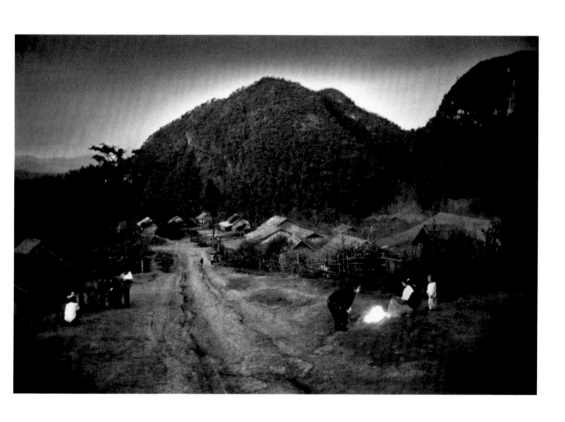

The headquarters of the Shan State Army at Loi Tai
Leng. Here refugees, together with families of Shan
insurgents, live in a camp that straddles several ridges
along Burma's mountainous border with Thailand.

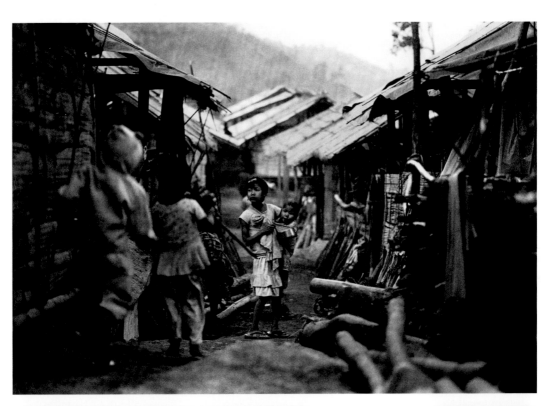

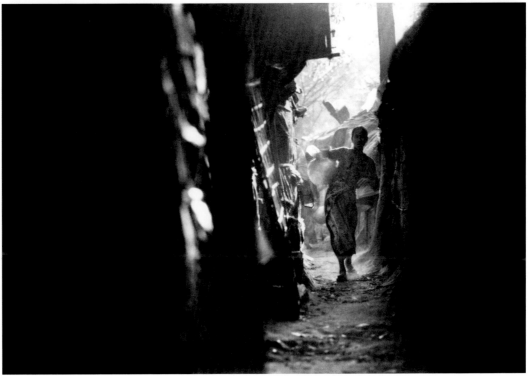

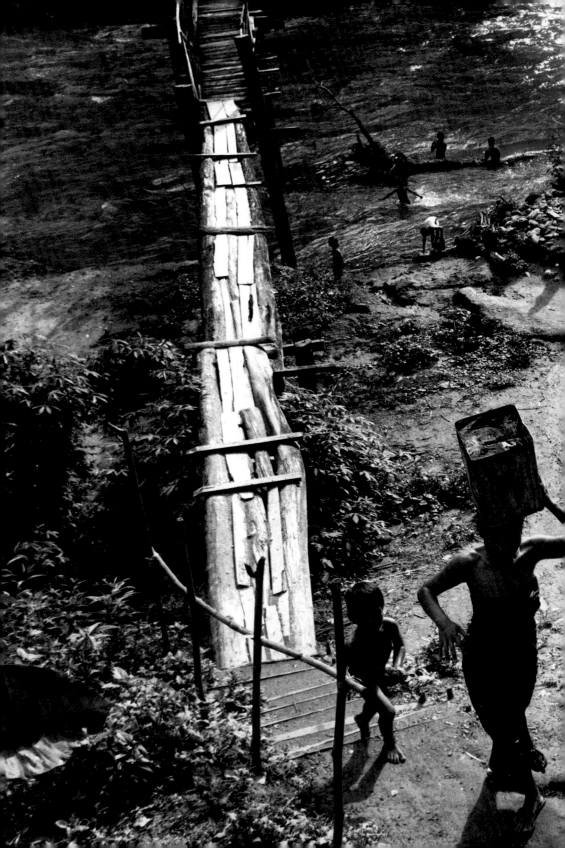

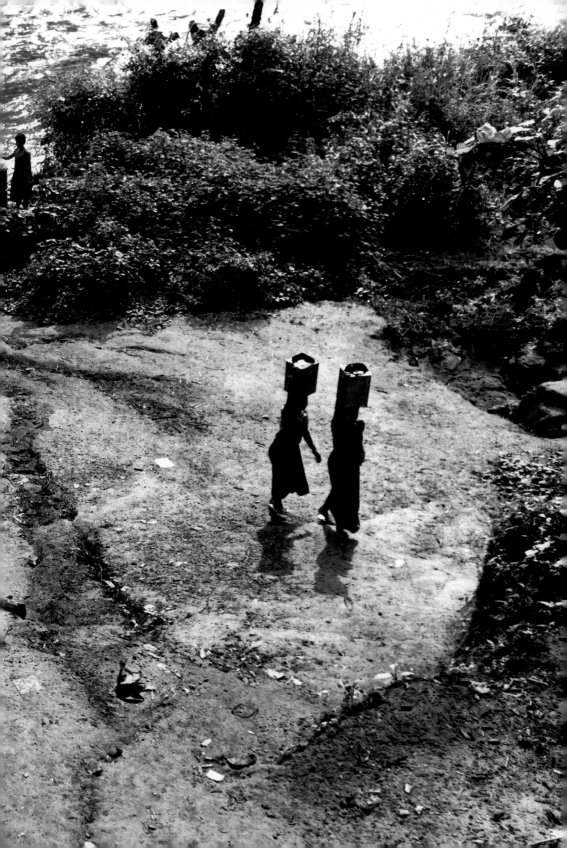

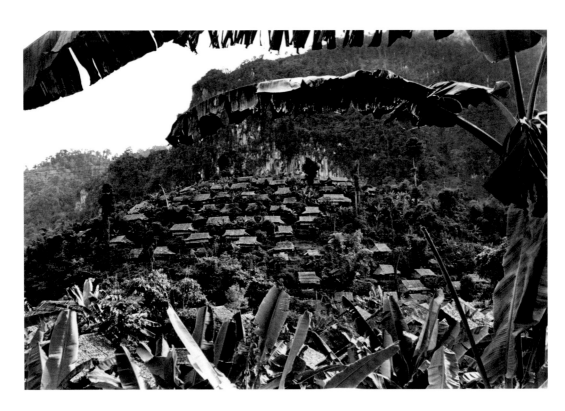

PREVIOUS SPREAD Fetching water: Sho Klo refugee camp on the Thai-Burma border.

Mae La refugee camp on the Thai-Burma border. By 2012, there were more than 140,000 refugees in Thailand who had fled the scorched earth policies of the Burmese army. In 2007 alone, more than 76,000 civilians fled their homes in Shan state and more than 160 villages were burnt to the ground. The number of refugees inside Burma was estimated to be over half a million.

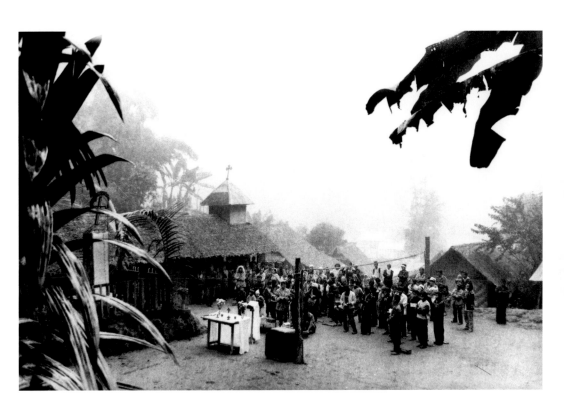

Karenni refugees attend mass in Nai Soi on the
Thai-Burma border. Many of the ethnic minorities
are Christian, unlike the Burman majority,
who are Buddhist.

OVERLEAF Mae La camp. In 1997, several camps
along the Thai border were consolidated to improve
security after being attacked in cross-border raids
by Burmese troops and their allies. The refugee
situation in Thailand is one of the most protracted
in the world.

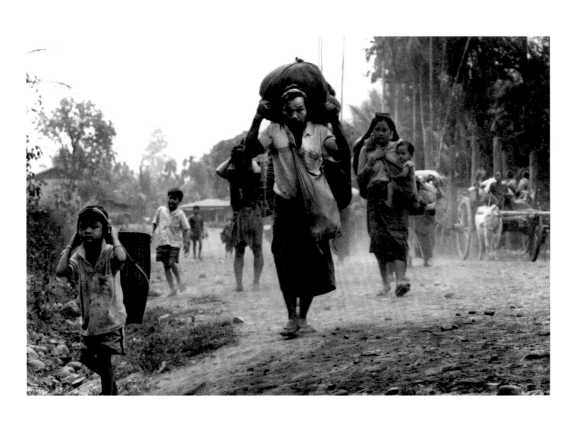

Baan Bun Klung. Karen refugees at the Thai-Burma
border during the Burmese army offensive of 1997.
Some 20,000 people fled the fighting, many of them
spilling over into Thailand.

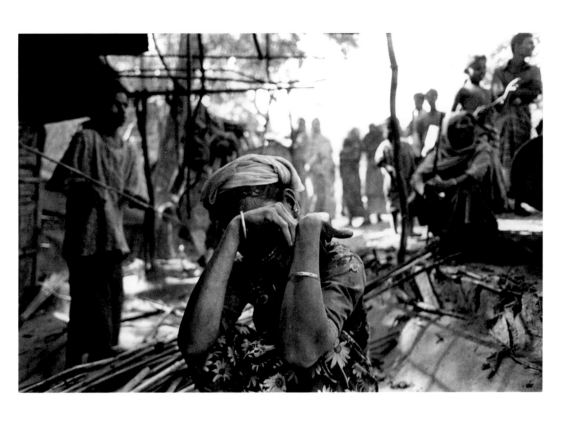

At the beginning of 2007, the Bangladeshi government began reclaiming land from illegal encroachment along the country's roads. These Rohingya refugees, who lived in a makeshift camp, were given 24 hours to move. They had nowhere to go.

57

A Rohingya woman at Dum Dum Mea camp
in Bangladesh.

"The Government of Burma says, 'This is not
your land.' Government of Bangladesh says,
'This is not your land.' So I ask you; I ask UNHCR;
I ask Bangladesh and Burma to please tell me,
where do I belong? Where is my home? Where
can I go? I do not want to be a refugee anymore.
I just want to live in peace."

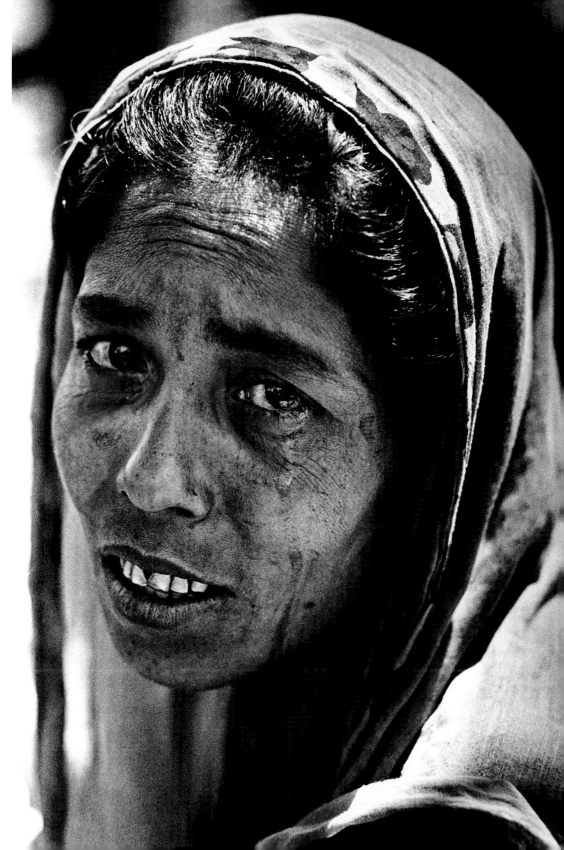

အသက်သွေးချွေးစဉ်မနေး
ပေးဆပ်သည်မှာ တပ်မတော်ပါ။

NEVER HESITATING ALWAYS

READY TO SACRIFICE BLOOD

AND SWEAT IS THE TATMADAW

THE INVISIBLE
DICTATORSHIP

*Witness and realise the reality and truth and this will replace
the criticism of Myanmar [Burma] abroad.*
Lt. Gen Khin Nyunt, Secretary Number One

In March 1962, General Ne Win seized control of Burma in a coup and set about isolating and unifying the country under military rule. He arrested most of the cabinet, abolished Parliament and appointed himself President. He established a state-run military intelligence network to keep watch on the population and jailed thousands of his opponents in the process.

Ne Win then embarked on the disastrous "Burmese Way to Socialism" – a blend of ideas that included Marxist and Buddhist influences. Under this programme, he nationalised industry and banks, collectivised agriculture and expelled all foreigners. This led to the virtual collapse of Burma's economy and its effective withdrawal from the world. In 1987, allegedly on advice from

his astrologer, Ne Win banned the 25, 35, 75 kyat notes introducing 45 and 90 kyat notes instead. Across the country, people found themselves instantaneously bankrupted and destitute. Shortly afterwards, the UN declared Burma one of the poorest countries in the world.

Although there had been protests in the past, the unrest this time was driven by near-universal economic misery. Frustrated by decades of mismanagement and repressive rule, the people took to the streets, calling for the restoration of democracy and an end to military domination. In an attempt to appease the protestors, the reclusive Ne Win appeared on state television and announced his resignation. Nevertheless, he continued with the threat that, should the protests persist, the army would open fire. "If the army shoots, it hits," he warned. "There will be no firing in the air as a warning."

The movement, now led by the students and numbering tens of thousands, continued to protest. The army was sent in and protesters fought running battles

with heavily armed soldiers in the streets of Rangoon. Aung San Suu Kyi was persuaded to join the movement in the hopes of bringing an end to the violence. But the army continued to open fire on demonstrators, killing thousands.

Eventually, the uprising was quelled and marshal law imposed. The military then began rounding up opponents and Aung San Suu Kyi was placed under house arrest. In 1990, the army attempted to restore a degree of legitimacy by holding elections. Political parties were allowed to form, but meetings of more than five people were banned. Despite her detention, Aung San Suu Kyi's party, the National League for Democracy (NLD), won a landslide victory. The junta refused to recognise the results and continued to jail and torture her supporters. The generals were back in control.

The massacres of 1988 precipitated a clean-up. The following year, Burma's military rulers, calling themselves the State Law and Order Restoration Council, changed the name of the country to Myanmar. They also changed the names of cities and towns, ostensibly to rid Burma of its colonial past (most of the old names having been Anglicised) and, at the same time, conveniently removed any associations with the bloodshed of 1988. In an attempt to tidy up the unsightliness of urban poverty, the regime forcibly relocated tens of thousands of the poor from central Rangoon to satellite towns, where they could be kept under control.

Whatever attempts the generals made to cover up the horrors of 1988, the crackdown marked a fundamental shift in the way people inside the country viewed the army.

The regime – now led by General Than Shwe – began to encourage tourism and foreign investment. "Visit Myanmar Year" was launched in 1996 in a bid to attract tourist dollars and gain international legitimacy. The regime released Aung San Suu Kyi from house arrest and it seemed as if the situation was improving. Lt. Gen Khin Nyunt, Secretary Number One, challenged tourists to "witness and realise the reality," believing this would "replace the criticism of Myanmar abroad". Tour companies bought into the programme and a positive spin was given to Burma's poverty. As one tour operator put it: "Decades of social and economic isolation have preserved many of the traditional features, physical and cultural, which have been lost in other countries."

But while the civil war rumbled on beyond designated tourist corridors, oppression in the cities was carefully concealed. The junta's gestural moves towards democracy went nowhere. Some foreign companies began to withdraw as it became apparent that business transactions were dominated by crony capitalism and corruption. Yet it was still possible to visit as an outsider and have no sense of what was really going on.

★

In 1995, I was commissioned by the Guardian Weekend magazine to photograph the dictatorship for a feature by John Pilger, entitled "The Burmese Gulag".

This was my first trip to Rangoon. I arrived at Mingladon airport on a fine day in December and took a taxi downtown.

Rather than an austere, oppressive atmosphere, I found a city alive with activity. Rangoon was a bustling metropolis of colourful markets, crumbling colonial buildings and gleaming pagodas. Street hawkers sold old copies of Life magazine and monks browsed pavement bookstalls next to tea shops full of men huddled around small tables.

The Guardian wanted colour photographs. Arriving in the cool season, when the skies are clear and the light golden, the photographs I took lent themselves more to travel photography than photojournalism. I decided that, the next time I returned to Burma, I would stick solely to black and white. I wanted to escape the travel-brochure surfaces of life and seek out the underlying mood.

As an object of curiosity, I was sure I was being watched. I walked the streets trying to look inconspicuous. I taped over the Nikon insignia of my cameras to look less "professional" and hid them from view (though I soon abandoned this idea when I spotted a Japanese tourist festooned with photographic paraphernalia). In order to blend in as just another tourist, my first stop was the famous Shwedagon pagoda in the centre of the city. I watched the faithful praying at the foot of the pagoda. Barefoot crowds wandered across the marble floor among monks in burgundy robes and nuns holding wine-coloured parasols. Women sold Buddha images and garlands, their cheeks smeared with tanaka (a Burmese cosmetic made from sandalwood).

Burma is not only ethnically diverse, it is home to a wide array of religious faiths. The dominant religion is Buddhism, tempered by a strong underscore of animist belief (with astrology and numerology taken very seriously). But there are also Baptist Christians, Catholics, Anglicans, Muslims, Hindus, Sikhs and even a small number of Jews. This colourful mix, coupled with the fading grandeur of Burma's colonial buildings, was not what I had expected.

For most visitors to Burma at that time, stories of slave labour and repression seemed at odds with the images they encountered: smiling people, exotic festivals and gleaming temples. Burma was a mature totalitarian state, its operations too subtle for the casual observer to perceive. There were tourist attractions built with slave labour, infrastructure projects developed on the sites of relocated villages, plain-clothes police on street corners. I wasn't sure how to fulfill my brief and take photographs that caught visible signs of oppression.

After some time, however, as if my eyes were becoming accustomed to the light, I began see the dictatorship everywhere: in the clusters of children repairing roads, in dilapidated buildings, in the hum of generators compensating for power shortages, in the poverty of the countryside. The regime was so ubiquitous there was no need for troops on the streets. The very absence of the army was proof of its power.

Living under a dictatorship, ordinary people found ways to hold on to their core political beliefs. I got to know one magazine editor who had managed to outsmart the censor and get clearance for an advert for the film 'V for Vendetta,'

despite the line which read: "People should not be afraid of their governments, governments should be afraid of their people." Small acts of resistance like this, I realised, kept people sane.

Others found elaborate ways to remain true to their values, while avoiding the attention of spies. I was befriended by Zaw Gyi, a former student who had taken part in protests against the regime in the early 1970s. He chattered away to me as we wandered the streets of Rangoon, speaking mostly in riddles. At the end of almost every sentence, he would ask with a grin: "You get my meaning?" One time we crossed the road near the Secretariat, where Suu Kyi's father, General Aung San, had been assassinated. Zaw Gyi held me back from the kerb and said: "This was where a student was killed by the British police." Then he winked and gave me an original passport-size photograph of Aung San. "You get my meaning?"

The street we were standing on was where, in 1938, British mounted-police had charged students picketing the Secretariat (the seat of colonial administration

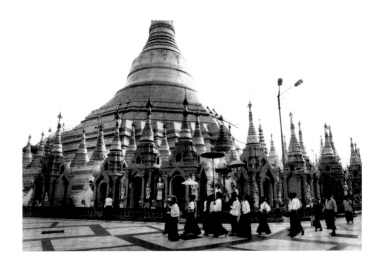

for Burma) with batons. Remembering that Aung San Suu Kyi had once described the popular movement for democracy as the second struggle for independence, I realised this was a veiled reference to the 1988 uprising.

Although most of the killing during 1988 had taken place in Rangoon, there had been other towns and cities which had seen their share of violence. In one town in Shan state, a woman called Nita – a member of Suu Kyi's party – showed me bullet holes in the wall of her home.

One morning, during 1988, her daughter had opened up the shop only to have Burmese troops open fire on their house. The daughter was shot in the head and killed instantly. The authorities ordered Nita to cement over the holes. She refused. She had even photographed her daughter's body lying in the doorway and carved out the bullets lodged on the brickwork to keep as evidence. Despite her loss, she believed in justice. Her husband, however, told me privately he didn't agree. He wanted revenge.

★

For a long time before I travelled to the Burmese interior, I had wanted
to photograph Aung San Suu Kyi.

As soon as she was released from house arrest, the world's media arrived
in Rangoon and her image began appearing everywhere (except in Burma,
of course, where it was banned by the censors). I knew exactly how I would
photograph her. With Alberto Korda's famous image of Che Guevara as my
starting point, I sketched the outline of the image in my notebook weeks in
advance, experimenting with ideas because I knew that, when the time came,
I would only have a few minutes.

Although Suu Kyi had been released from house arrest, her movements were
severely restricted. The first time I took her picture, she was speaking from the
gate of her home on University Avenue. Thousands braved the regime to see her
in what had become a weekly ritual. When she appeared, the crowd cheered and
clapped. The atmosphere was festive. Speaking through a microphone, she seemed
to play to the crowd in a flamboyant manner that delighted them. With the
international media, by contrast, this slight woman could be intimidating.
I had seen her bluntly dismiss journalists who had not done their homework.
"I often find it quite exhausting to pose for photographers," she once wrote.
"It is good to sit for photographers who are able to explain precisely what they
would like you to do but who, at the same time, remain fully aware that you
are a human being."

I was apprehensive of taking her portrait alone. Together with a friend, I
arrived at the gate of her family home on a gloomy day during the rainy season.
We had to sign a visitors' book at a small hut for the Military Intelligence agents
who guarded her gate. Inside, it was dark and spartan. Photographs of her famous
father hung on mildewed walls. Others had been moved and left an outline,
perhaps sold for food during her years of incarceration.

The door swung open and Aung San Suu Kyi swept in. The first thing I noticed
was how small she was: stiff and formal. It was only after an interview with
my friend that she began to relax. She talked about how the soldiers never act
on their own initiative and only do something when they are given orders.
We laughed at the crude government billboards that had been erected by the
regime. Then I asked if she would pose.

I stood her at the entrance to her family home with the door open. The
contrasting darkness of the interior provided a natural outline. I asked her
to fold her arms in the way I had sketched, so that she looked a little impatient
– that she, like the people of Burma, had been waiting for years for what was
rightfully theirs. To reinforce that idea, I asked her to look sideways as though
she had been interrupted mid-conversation by the camera. In Korda's photograph,
Guevara looks into a distant revolutionary future above and beyond the viewer.
I wanted Suu Kyi to look straight into the lens for an intimacy that bordered
on accusation. I didn't ask her to smile.

It was the last time I was to photograph Suu Kyi for more than a decade. Her duel with the military continued and she was twice again placed under house arrest, becoming the world's most famous political prisoner. The last time she was incarcerated was after she narrowly escaped an assassination attempt by the junta.

MASSACRE AT DEPAYIN

On May 30, 2003, while touring up-country, Aung San Suu Kyi's convoy was attacked by a government-controlled mob, organised by the regime near Depayin in Sagaing division. Believed to have been an assassination attempt by the junta, as many as 70 members of her party were reportedly beaten to death. Many more were wounded. Aung San Suu Kyi and party vice chairman U Tin Oo managed to escape. Many others were imprisoned or remain unaccounted for. Events of that day were described to me by Khin Aye Myint, a member of Suu Kyi's party:

"It was about eight in the evening and it was totally dark. I was in front

of Aung San Suu Kyi's car. U Tin Oo's car was in front of mine. Our motorcade was suddenly surrounded by large trucks, full of thugs waiting for us.

"I saw many monks wearing yellow masks on the road. At first, I thought these monks had come to welcome us. Then they ordered Aung San Suu Kyi and U Tin Oo's cars to stop. The male members of the NLD, who were in the motorcade, told the female members not to get out of the cars. When I looked behind, I saw the people from Kyi village – who had previously welcomed us – being beaten by thugs who had got down from the trucks. Just after we got out, more thugs ran and attacked us with iron and bamboo poles. They also attacked our motorcade with stones, which they carried in bags. We were lucky. The car I was in had a roof. There was nothing we could do except wait for them to come and kill us.

"While we were hiding from a hail of stones, they came and grabbed our NLD icons and bracelets. They screamed at us and forced us to take off all our tops.

"They knew we were Burmese, but they screamed that we were 'American

women' and dragged us out of the cars and began beating us about our heads. While they were beating us, they said: 'You bitches who count on America. Uncle Than Shwe paves roads and builds bridges, what is your problem? Why can't your Kala ma [a derogatory term, meaning female foreigner: a reference to Aung San Suu Kyi] act like him? You are using the roads that we paved.' The car behind me was now burning. I could see other NLD members being beaten with batons. Then I was pulled down from my car and beaten. After receiving three violent beatings, I fell into a field beside the road. I was left wearing only my skirt.

"I could not move, but I didn't lose consciousness. They left me for dead because I was covered in blood. I heard them say, 'One more woman who relies on America has died.' And they kicked me. Then they left me. I could not move or concentrate. I heard people being hit, screams, people begging for mercy and groaning. They beat anybody who was still making a noise. After the attack, they got back into their cars and headed towards Monywa.

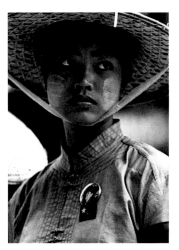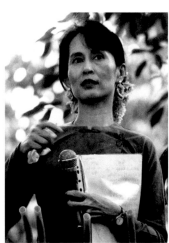

"There was blood everywhere. A male NLD member gave three of us shirts to wear. I tried to help other wounded people by cleaning and bandaging their injuries. People were crying out for help.

"I saw that our driver, Ko San Myat, was dead on his back and that another youth member named Thein Toe was dying. Ko Tin Maung Oo gripped my arm for help. He asked me to take care of his daughter. I told him, 'Don't lose your hope. Be strong.' I helped him to drink, but he was dying.

"I then fell unconscious on the road. Later, somebody stepped on me. When they realised that I was alive, they said that they would get me to a safer place. Some female members carried me to a field. The staccato sound of gunfire went on all night. At about midnight, troops came and carried away all the dead bodies. They did this using a list. I heard them asking for and confirming the car licence numbers. How many had been in which car, how many died, how many had been injured and how many were missing. Then they left.

"The troops who came to carry away the bodies had guns with bayonets. They moved our cars to make it look like there had been an accident. I saw them cut down branches from the trees beside the road and create an accident scene, as if our cars had crashed into trees. After this, they took pictures of the supposed evidence. They tried to round up the rest of the NLD members who were still alive. 'What are you doing here?' they shouted. 'You have no business being here. Why did you come here if you are from Mandalay?' Our members replied that they had come with Aung San Suu Kyi. Later, they tried to round up any remaining people who were still alive.

"In the morning, we walked slowly to the surrounding villages via a jungle route. When we arrived at the villages, we tried to rent carts, but nobody dared to lend them to us because we were all stained with blood. At one place an abbot asked us, 'Are you NLD members?' When we said we were, the abbot took us to his monastery. He helped us by cleaning our wounds and giving us clothes and slippers.

"I saw many men in police uniforms on the night of the attack. The people who hid with us in the field were arrested and imprisoned. We were lucky. We weren't arrested because we went in the opposite direction.

"Everything about the massacre was well planned. Everything they did appeared to be in accordance with a schedule, like a drill. They called to their groups using secret codes. They were just looking for an excuse to ban the NLD and to crack down on Aung San Suu Kyi. Her life wasn't intentionally spared. When the troops attacked, they had the order to kill her. My brother was in the car with her and drove away desperately to save her. She was lucky, that's all."

Tourists and the truth

By the mid 1990s, month-long tourist visas were being handed out and international journalists took advantage of this new freedom. As more foreigners visited Burma, the regime realised that it also risked having some of its abuses exposed to the outside world.

On several occasions, plain-clothes officials tried to prevent me from photographing children working on road construction. In 1995, I had spent several hours with a group of prisoners guarded by the Tatmadaw outside Mandalay palace who were constructing a road. They were friendly and, although the soldiers were camera shy, I did manage to get photographs of both prisoners and soldiers in the same frame. Later, it was deemed illegal to photograph soldiers and prisoners. But the further afield I went, the less savvy the authorities were. In Shan state, I simply walked into a quarry where I knew a chain gang of prisoners was working, smiled at the guard, took some photographs of the prisoners, apologised and walked out again. No one took my film and no one followed me back to my guest house.

Along with fellow journalists, I often indulged in the paranoia which made us feel absurdly self-important. I would hide my film in the toilets of guest houses, my head full of stories of how "they" were watching us. But I came

to realise that, for the most part, they were less interested in the foreign media than whom we might meet: those were the people to worry about. The worst that would happen to a foreigner would be a brief interrogation, the confiscation of film and notes and then an unceremonious bundling onto a plane back to Bangkok. For the Burmese, however, it could mean arrest, torture and a hefty jail sentence.

I kept my meetings with Burmese friends to a minimum and preferred to work alone.

FORCED RELOCATIONS

For visitors to Burma, the removal of entire villages to make way for state-sponsored projects is among the least visible aspects of the regime's power. In Moulmein, I wandered around the outskirts of the town to find hundreds of families taking apart their homes. They had been ordered – literally – to pack

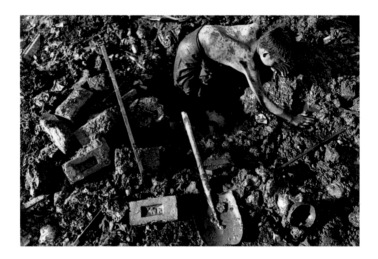

up their wooden houses and move them to another site to make way for an expansion of the naval base.

Perhaps the most infamous case of forced relocation took place in the ancient capital of Pagan. Situated on the banks of the Irrawaddy River, the old capital is a vast area of crumbling stupas and one of the main stops for tourists.

In May 1990, more than 5,000 residents of old Pagan were forcibly relocated to an area more than 7km away in an exposed and arid part of the plain. Some 2,000 soldiers were deployed to ensure the people moved. Those who protested were thrown in jail. One man showed me the spot where he and ten members of his family had once lived. This man's family were given nothing in the way of compensation. "If you didn't move," he told me, "they shoot."

It was in Pagan that I met the German owner of a tour company who complained of the bad press Burma was getting, saying the reports of slave labour and abuse were grossly exaggerated.

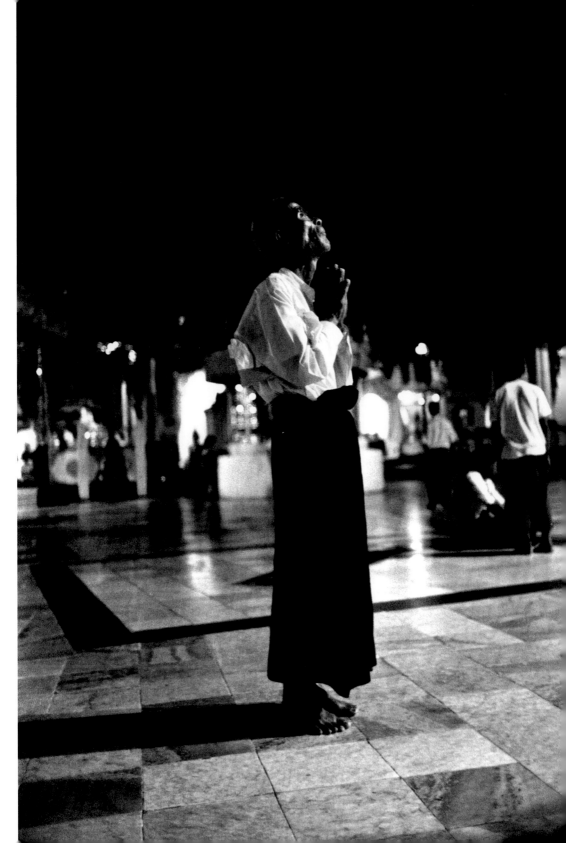

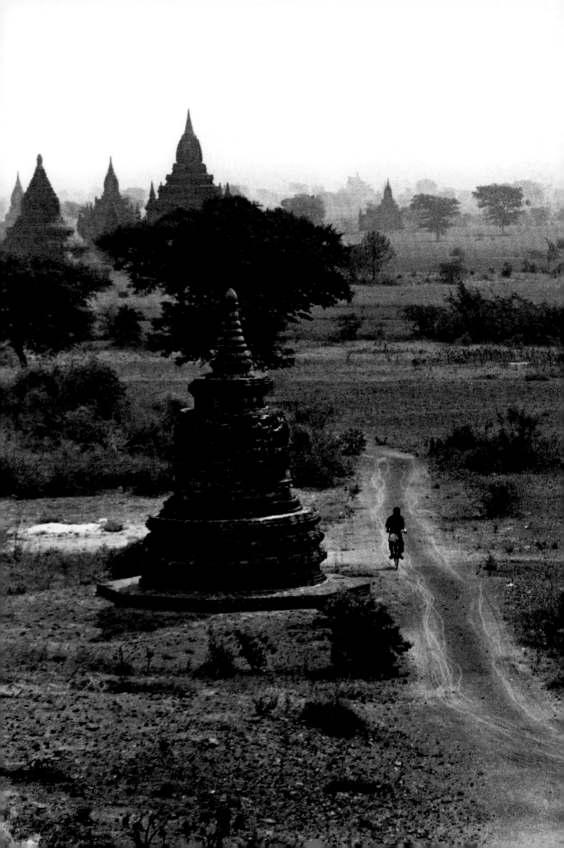

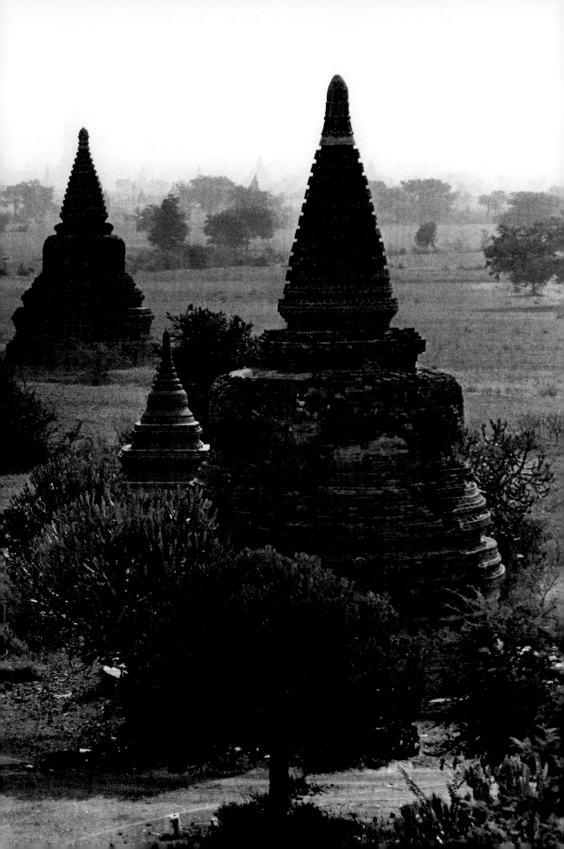

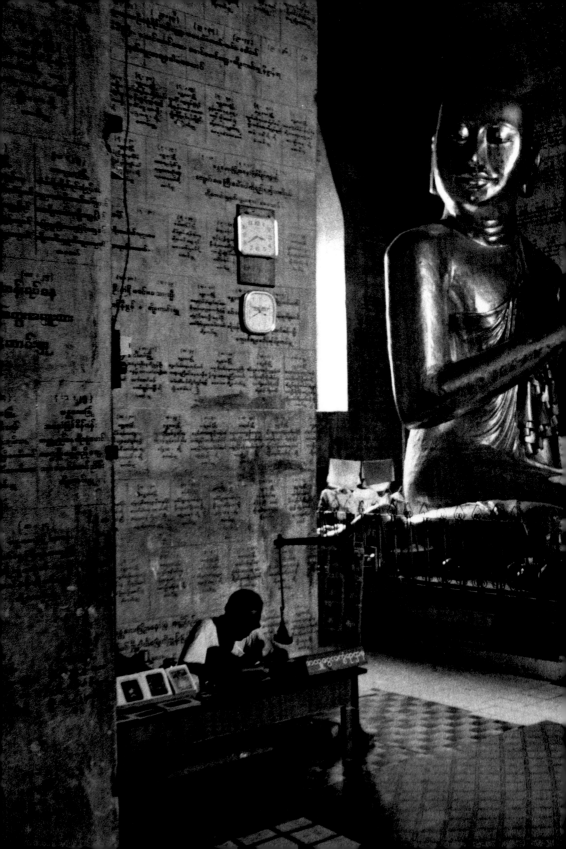

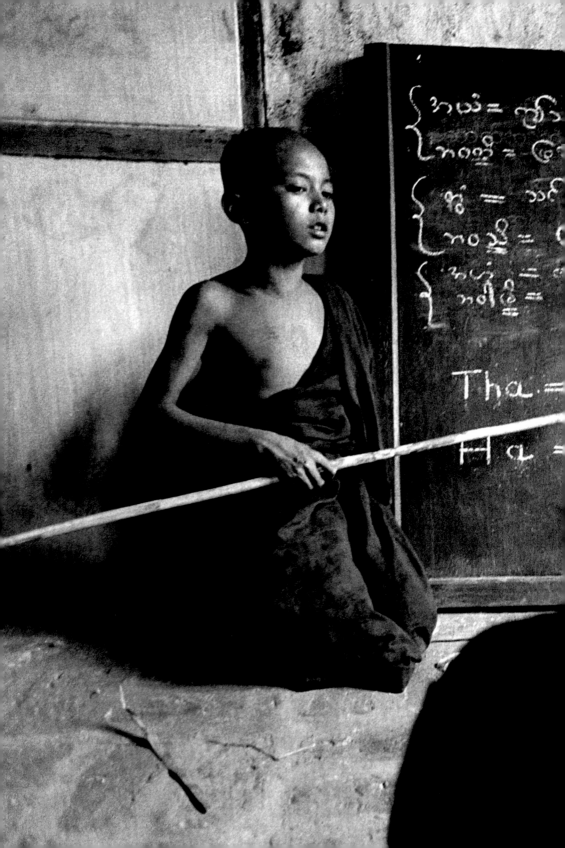

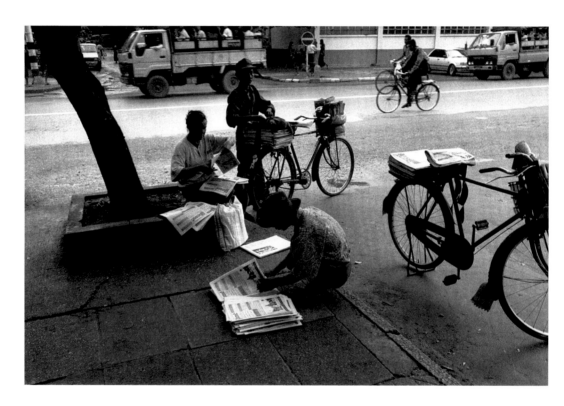

PREVIOUS SPREADS The ancient Burmese capital
of Pagan, Mandalay Division.

Mandalay Hill.

Buddhist novices attend class in Mandalay. Burma
was once considered one of the most literate societies
in southeast Asia. Under military rule, education
suffered serious setbacks as the junta restricted
what could be taught. For those from poorer families,
an education at the temple is the only option. The
children of the junta's elite study overseas, ensuring
their place at the top of a privileged hierarchy.

Burma's media have long been heavily censored,
with anything "detrimental to the ideology of
the state" prohibited. Many journalists have been
imprisoned by the junta.

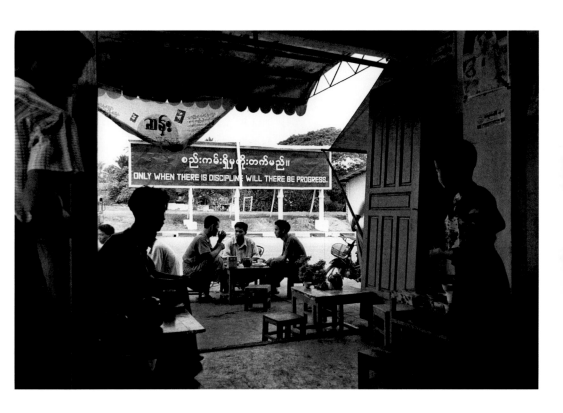

Pa An, Karen state, 1997. Teashops are the traditional
forums for discussion and debate in Burma.
The positioning of the signboard may be accidental,
but the 1988 uprising began after an incident at a
teashop in Rangoon.

OVERLEAF Downtown Rangoon, 2005. Military
Intelligence agents and informers kept a close eye
on the activities of the young.

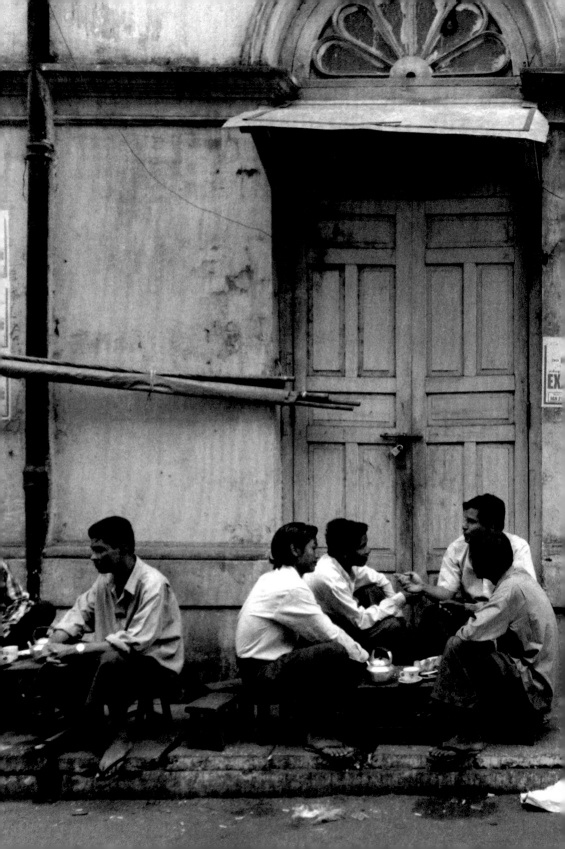

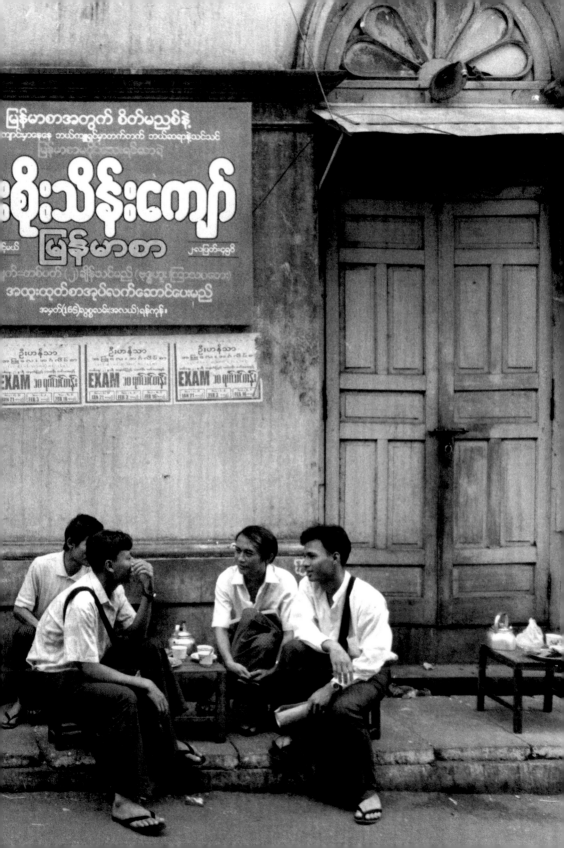

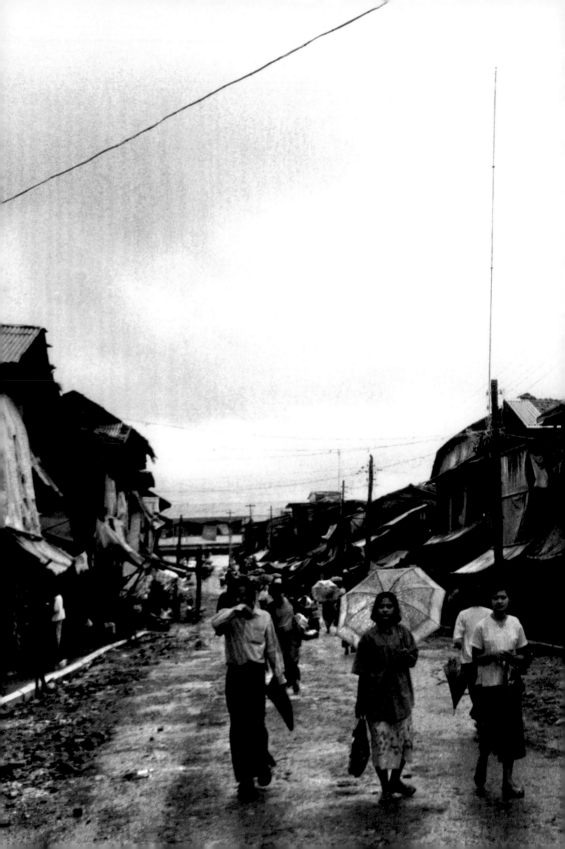

·

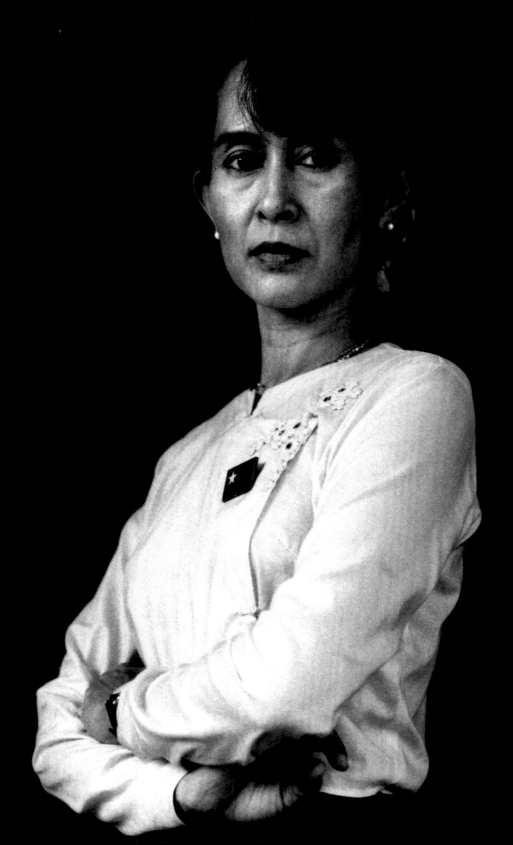

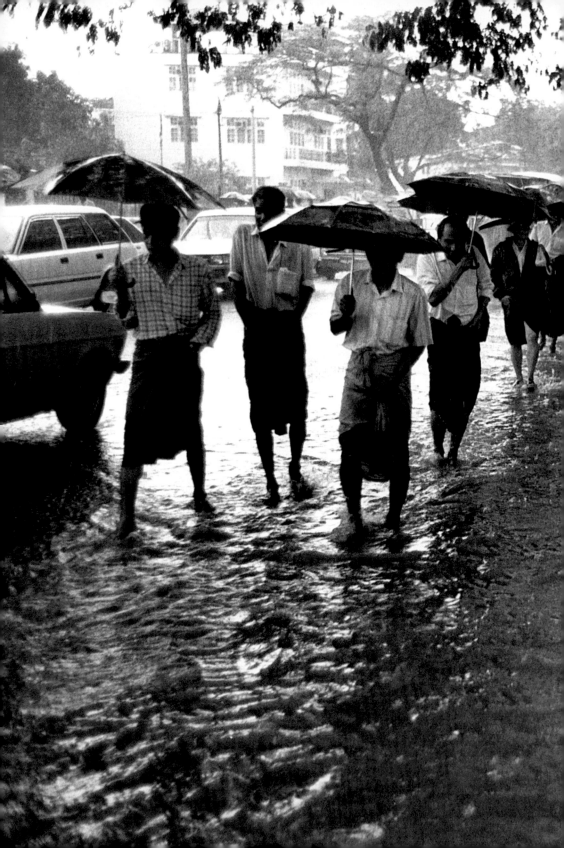

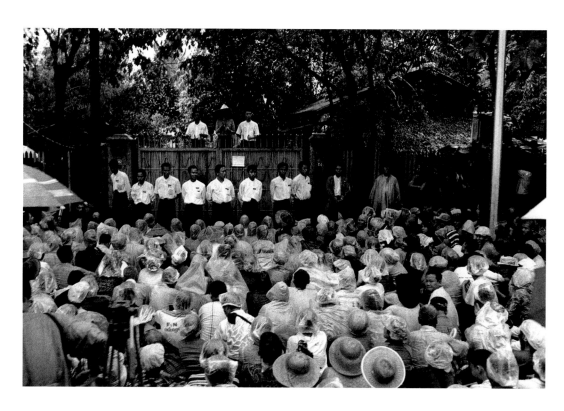

PREVIOUS SPREAD When the military junta
released Aung San Suu Kyi from her first term under
house arrest, her movements were restricted. She
began to address crowds of supporters at the gate
of her Rangoon home on the weekends. Thousands
defied the junta's spies to hear her speak.

Flanked by her bodyguards, Aung San Suu Kyi
addresses her supporters at her gate. All her speeches
were videotaped by the regime. Military Intelligence
officers set themselves up on the opposite side
of the road behind a small wall of corrugated iron
(left of tree). Agents would mingle with the crowds
and take pictures of Suu Kyi's supporters. In 1997,
these speeches were closed down altogether.

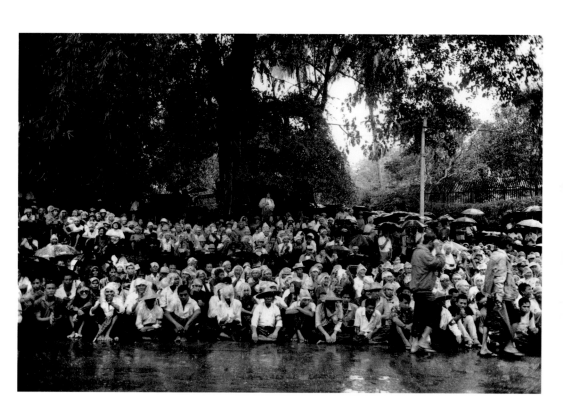

OVERLEAF NLD youth members on University
Avenue. Careful not to give the regime any excuse
to crack down on these meetings, the NLD youth did
their best to organise the crowds and keep the roads
clear for traffic.

A meeting of the National League for Democracy executive committee in Aung San Suu Kyi's home in Rangoon. Photographs of her famous father hang on the walls. These meetings were held in a siege-like atmosphere. Outside, Military Intelligence agents kept a 24-hour vigil. Anyone entering or leaving had to register at their hut inside the gate. People were often followed and, on occasion, arrested.

OVERLEAF The executives of the NLD: from left to right, U Aung Shwe, U Kyi Maung, U Tin Oo, Daw Aung San Suu Kyi and U Lwin. All of her colleagues had served in the military. U Kyi Maung was imprisoned twice on suspicion of opposing the army.

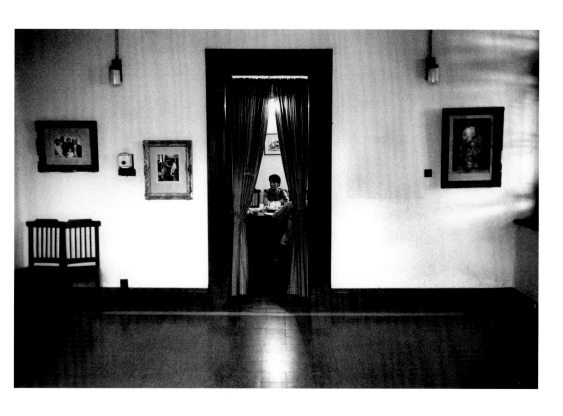

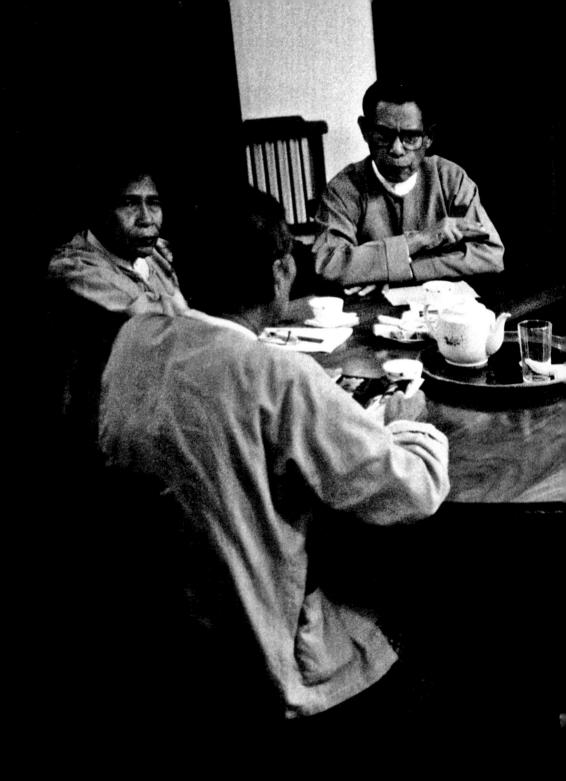

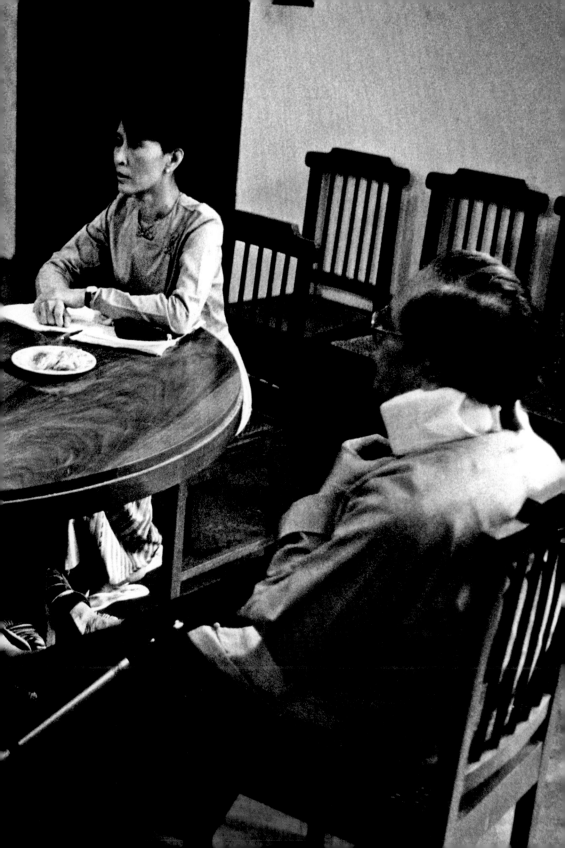

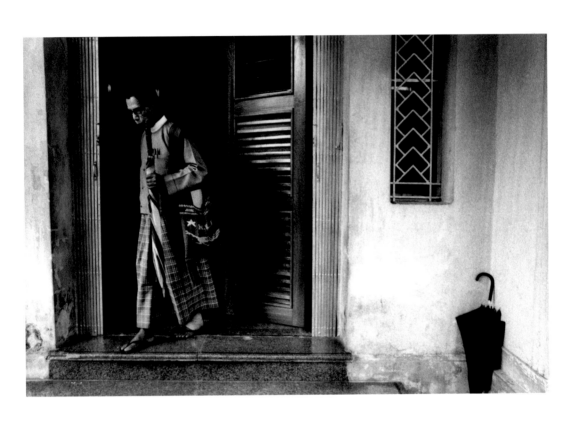

U Tin Oo leaves Suu Kyi's house after the meeting.
Vice chairman of the National League for Democracy,
he served 12 years in Rangoon's infamous Insein prison.

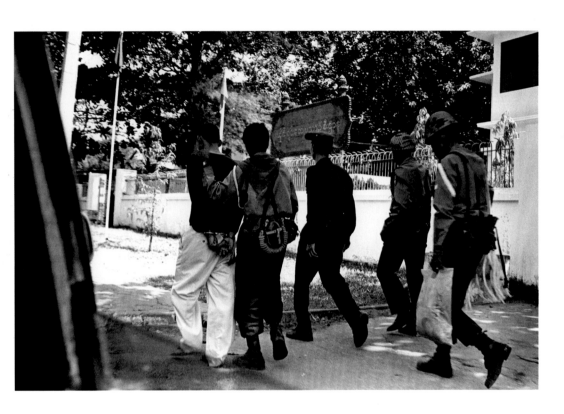

A handcuffed man is led away by police and an
intelligence officer in Rangoon. He may have been
a common criminal, an assassin or simply an ordinary
citizen in the wrong place at the wrong time. In Burma,
calling for basic human rights under the dictatorship
was treated as a criminal offence. The junta made no
distinction between political activists and criminals:
both were enemies of the state.

အမိနိုင်ငံတော်ကိုချစ်ပါ၊
ဥပဒေကိုလေးစားပါ။

LOVE YOUR MOTHERLAND

RESPECT THE LAW

BURMA'S
GULAG

The essential fact about a totalitarian regime is that it has no laws. People are not punished for specific offences, but because they are considered to be politically or intellectually undesirable. What they have done or not is irrelevant.

George Orwell, who served as a colonial policeman in Burma from 1922 to 1927

In 1996, a close friend of Aung San Suu Kyi, Leo Nichols, died in Rangoon's Insein prison. An Anglo-Burmese businessman, Nichols was also honorary consul for Norway and Denmark. At 65, he suffered from hypertension, a weak heart and diabetes. His crime was to possess an unregistered fax machine. The authorities denied him the medicine that would have saved his life.

By 2006, there were believed to be more than 1,500 political prisoners in Burma. The exact number was impossible to calculate because the junta made no distinction between criminal and political prisoners. In some cases political prisoners were arrested and incarcerated on criminal charges. There was no due process and prisoners were not allowed a lawyer or given the opportunity to defend themselves in court. Hearings usually lasted 15 minutes, with the judge reading out the charge and then the sentence. Very often they were tortured into signing confessions to crimes they hadn't committed.

Whether in prison or at one of the many interrogation camps run by Military Intelligence, torture had become routine. It took the form of both physical and psychological abuse. The physical ranged from being forced to stand in stress positions, where prisoners had to hold difficult poses for lengthy periods of time, to beatings and electrocution. Many described having metal bars rolled up and down their shins – an agonising practice that rips off skin. But torture could also be purely psychological.

One former political prisoner described how a gun was held to his head. His interrogators threatened to kill him if he didn't give them the "correct" answers to their questions. Another described being stripped naked and made to watch the interrogation of others as they were beaten: "I saw several people lying on the floor, bloody and unconscious."

Prison cells were – and remain – overcrowded and unsanitary. Insein prison in Rangoon was built to hold 2,500 prisoners. By 2006, it held 10,000. Political prisoners were regularly placed in solitary confinement from a period of a few days to several years. Min Ko Naing, the student leader from the 1988 uprising, was held in solitary for almost 16 years. The conditions were far worse than in regular cells. The room was smaller and prisoners were placed in punishment shackles with a metre-long iron bar that separates the ankles at all times. They had to sleep on a cold concrete floor without a mat or blanket and were not allowed to shower. The pots for faeces and urine were not emptied; maggots spread; the stench would become unbearable.

Officials acted with total impunity, safe in the knowledge that prisoners were considered "destructive elements" by the regime. Murder was sanctioned. At least 127 political prisoners died in custody. Families were usually informed of a death after the body had been cremated. Death certificates were falsified and family

members offered bribes to remain silent about the true cause of death. No prison guard or officer has ever been brought to account for the abuse of a prisoner.

Many political prisoners were sentenced to a number of years with hard labour. The work involved breaking rock, clearing forest, carrying water and tilling fields. Mixed with convicts, some of the inmates in these camps were as young as 14. It is estimated that as many as 20 percent of prisoners sentenced to prison with hard labour died. There were at least 91 labour camps across Burma. Prisoners worked 12-hour days without rest. The sick and weak were not exempt. In one quarry, I watched a prisoner collapse, exhausted from carrying large rocks up the quarry face in chains. The camps were usually located far from urban centres, making it difficult, and often impossible, for families to visit. The isolation was another aspect of the torture, designed to break political prisoners. Countless reports of torture, beatings and killings have emerged from the camps.

On occasion, prisoners were used to porter for Burmese troops in frontline areas. They carried ammunition and supplies in mine-infested forest where insurgents were operating. I spoke to a former inmate who, despite completing his jail term, was taken off to carry supplies for the military with 80 other prisoners. He managed to escape, but not before the troops realised. They opened fire and shot him through the arm. After several days in the forest, he arrived in Thailand where a policeman took him to hospital. Others were not so lucky. Many were forced to walk ahead of columns through minefields. Some died of disease or were simply shot when they become too sick to carry their loads.

Bo Kyi

A final-year student at Rangoon University, Bo Kyi became actively involved in the pro-democracy uprising of 1988. He was a personal aid to Min Ko Naing, the general secretary of the All Burma Federation of Student Unions, which spearheaded the movement before it was crushed by the junta.

In 1990, after a year in hiding, Bo Kyi was arrested and taken to Insein prison and sentenced to three years hard labour by a military tribunal. No plea of innocence or guilt was permitted and no lawyer was present. The entire proceeding took 20 minutes. Bo Kyi's "crime" had been to organise a demonstration calling for the release of all political prisoners and to recognise the union as a legal organisation.

He was put in a small cell with a bed, a table, two chairs and a light bulb. He was ordered to stand for long periods of time and forced into positions such as "the motorcycle," in which prisoners have to mimic driving a motorbike with bent knees and hands outstretched, making the sounds of changing gears. "My feet became swollen because of the long hours of standing," he said. "After a time, I couldn't wear my sandals any longer and, eventually, I couldn't stand up. They kicked me and punched me in the stomach." He was blindfolded and asked about his connections with armed ethnic groups along the Thai border,

which he denied. Unhappy with his answers, they continued to beat him, screaming obscenities and accusing him of being a traitor and a lackey of the United States.

When an activist was arrested in Burma, he would be expected to hold out for three days in order to give his comrades enough time to escape, before giving names. "At first when they interrogated and tortured me, they pressured me to become an informer for them," said Bo Kyi. "They told me that, if I agreed, I would be released immediately. That was the incentive, along with the threats and torture. It was either stay in prison or work with them." He refused.

The interrogation lasted eight days and nights. "Finally, I said to them 'I will sign the paper and you can write whatever you like.' They weren't happy with that and told me, 'you must say something.' I said, 'OK, I can say what I have done; the demonstration, the organising of the students. That's what I did.' Eventually, they agreed. Then I was sent to prison."

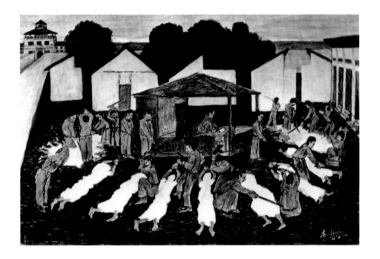

In jail, prisoners were beaten for the most minor infractions. One time, the prison authorities found 500 kyat in Bo Kyi's room. They beat him with a rubber truncheon and a chain made of leather. "I was once beaten every day for two weeks. On the first day I was beaten at least 200 times, until I lost consciousness."

In 1990, some political prisoners mounted a strike to protest about prison conditions, demanding the regime open a dialogue with Aung San Suu Kyi. They were taken out and beaten relentlessly by the guards, who were armed with sticks. During this time, known as "Black September", the prison doctor was present to ensure that beatings were controlled. He was heard by one prisoner to say to the guards, "You can continue beating – he's not dead yet." One of Bo Kyi's comrades was left paralysed from the neck down. He remains bed-ridden to this day.

Bo Kyi was placed in solitary confinement for a year. The cell was small and dark and he was allowed just a single exercise period of 15 minutes a day.

Family visits were not permitted. On other occasions, he was put in crowded cells with criminal prisoners as part of a standard process designed to break the will of political prisoners.

It was in prison that Bo Kyi taught himself English. He managed to get the guards to smuggle in pages of a dictionary and he would practise by writing on the floor of his cell with a piece of brick. In the cell next to him was a professor who could speak English. "When the prison guard was away I tried to speak with him and he would tell me one sentence of English and I wrote it down on the concrete and then recited it."

The food in prison was poor and the rice very low-quality. "Sometimes the rice gruel had grains of sand in it. Sometimes we had to clean the plates before we could eat. We called this 'doing an election' (prison slang for picking out rice that was edible)."

There was a lot of violence in prison. At one time, a prisoner was killed. He was a former military officer who had been arrested on charges of corruption. He had become a gang leader in prison. He was murdered by a prison guard with a nail to the head. There were also former child soldiers there who had been forced to join up and then escaped only to be arrested for desertion. Many of them were sexually abused by the more senior criminal prisoners. When children arrived, explained Bo Kyi, they were given jobs by the older prisoners who offered protection in exchange for sexual favours. If the children refused, they were given dirty jobs, denied food, or beaten. Eventually, they all relented.

Bo Kyi was released in 1998, after eight years. He found himself outside the prison gates, 70 kilometres from Rangoon with no money to get home. The guards gave him some so that he could begin to make his way back. "I didn't feel free," he said. "It was only me being released; the rest of my comrades remained in prison."

After being released, many political prisoners had difficulty readjusting. Outside, they would be ignored and avoided because of people's fear of attracting the unwarranted attention of the junta. They were closely watched by the authorities and, as a result, found it difficult to get work because people were afraid to employ them. Often Bo Kyi would get into fights with his friends. "I was angry," he said. In jail, political prisoners had an identity, a common goal. Outside, their sacrifices and deprivations seemed forgotten. No one wanted to talk about the continuing oppression. "I was a stranger in my own home. I even needed help crossing the road. I couldn't calculate the speed of the cars. I hadn't seen a car for years." The sights and sounds of the city were difficult to deal with and some ex-prisoners went blind. "My eyes and ears, or my brain, couldn't bear it," said Bo Kyi. "I felt dizzy and wanted to be alone."

In 1999, realising the intimidation and harassment from the authorities wasn't going to let up, Bo Kyi fled to Thailand. On the Thai border, he and a fellow ex-prisoner, Ko Tate, set up the Assistance Association for Political Prisoners in Burma. AAPPB provides financial support to prisoners and their families and operates with the Working Group on Arbitrary Detention under

the United Nations Commissioner for Human Rights. They lobby policy-makers in the US, the European Union and the Association of South East Asian Nations to put pressure on the regime to release political prisoners and raise awareness.

Today, as joint secretary of the AAPPB, Bo Kyi travels all over the world to promote human rights and democracy in Burma. He has been offered political asylum, but refused, believing that his role is to advocate for basic rights in his country. "If I wanted to stay in the United States, it would be very easy. The United Nations High Commissioner for Refugees told me that I should go to Norway, but I said no. They said that they couldn't protect me anymore, because I don't follow their procedures. I said, 'I can protect myself.' Many of our comrades are still in prison; some of them have died there. Some were shot and killed during the crackdown. They sacrificed their lives trying to restore democracy in Burma. How can I forget their faces? I am still alive, so I have to continue.

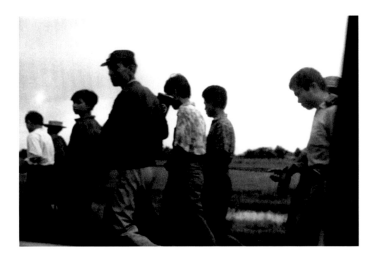

"Even the British treated prisoners better," he said. "There is no rule of law in Burma. That's the problem. Everything is controlled by the military regime. The first priority is that the judiciary must be independent. Without that independence we can't have fair trials."

However, Bo Kyi does not believe that overthrowing the regime is the answer. "We have to work together," he said. "We understand the role of the army in the country." The main problem in Burma, he said, has been political equality. "This problem began because the ethnic peoples were never given equal rights. Many Burmese people need to know how ethnic people are tortured and raped," he says. "Before 1988, we didn't really know how ethnic people were suffering in the border areas. In the newspapers, the government talked about the insurgency. After 1988, we realised that it wasn't an insurgency, it was a resistance. After 1988, I understood why they resisted. We need to educate them as well. Before 1988, they hated Burmans. Now, 20 years later, they understand more."

Bo Kyi continues his work from Thailand with Ko Tate. He is married, with a young son. But, like thousands of others, he remains scarred by his time in prison. The psychological torture was by far the worst he said. "It affects you for the rest of your life." He has a reoccurring nightmare, in which he is followed. "I run away and finally they catch up with me and they put the hood on me." The nightmare ends when the hood is placed over his head. "I wake up screaming. Even though I have been here in Thailand for five years now, the nightmares continue."

Bo Kyi is under no illusions. He believes that whatever change is now taking place, it will be a long process. "We need to be wise, we need to be patient, but first we need to sit down and talk."

For years, the democratic opposition in Burma, together with Western governments, demanded the unconditional release of all political prisoners as the first step in any negotiations with the regime. Since 2011, as part of a series of reforms that have swept the country, more than 600 political detainees have been released. The number of political prisoners still incarcerated is not known. The UN special rapporteur on Burma, Tomás Ojea Quintana, says there remain "serious and ongoing human rights concerns", including "continuing allegations of torture and ill-treatment during interrogation".

FORCED AND CHILD LABOUR

Burma was long referred to as a prison without bars. Next to prison labour was the practice of slave labour. The regime called this "voluntary" or "traditional" labour. Alongside prisoners, villagers are routinely rounded up and forced to work on state-run projects: from the building of roads to constructing military bases and, in some cases, labouring on commercial projects. In the run up to "Visit Myanmar Year" in 1996, hundreds of thousands of ordinary people, as well as prisoners, were forced to work on projects all over the country to prepare for tourists. As Zin Linn, another former political prisoner wrote: "Eventually, we became aware of the significance of these mass arrests. In order to build roads, bridges, railways, airports, dams, irrigation canals and even pagodas, the junta relies heavily on forced labour. Ironically, the junta undertook many of these infrastructure projects to demonstrate to the international community that it was ruling Burma in a noble-minded manner."

The military would typically demand labour from local villages, with the threat of fines or arrest if households were unable to supply the required amount of people. Impoverished villagers would be taken away from their land and livelihoods, sometimes for weeks or months on end. Threats, harassment, beatings and even killings were common and women risked sexual abuse, particularly in ethnic areas.

In Shan state, I went with a member of Suu Kyi's party who, at considerable risk to himself, volunteered to assist me in finding forced labour in the countryside. It was merely a matter of finding which village's turn it was that week. Before long, we found a group of villagers working in some maize fields on military

land. Nearby, there was a hut where soldiers in civilian clothes were watching over the workers. Through my colleague, I asked the soldiers who owned the crop. They held up an empty sack for the corn with the logo of a Thai multinational – called CP – emblazoned on it. They saw nothing wrong with the fact that the workers were not being paid. They were simply following orders.

Most heavy construction in Burma would be carried out by hand. It was common to see groups of children working on road-widening projects. Child labour isn't unique to Burma – children all over southeast Asia are expected to help with family chores, from drawing water to harvesting rice. But in Burma, after years of economic mismanagement by the junta, children would often drop out of school to help their impoverished families to earn a living. They usually found work as labourers on government construction projects and were paid a pittance. One group of children I spoke to, who were building a road, were paid 500 kyats (50 cents) a day plus two-and-a-half cups of rice from a condensed milk can. These children had passed primary school, but then dropped out to support families. All over the country, young boys from rural areas could be found working in tea shops. They were paid about 3,000 kyats (3 USD) per month plus food and a bed. Often they left home because their families could no longer feed them. Sometimes, they did not see their families for years because they couldn't afford to go home and were given no time off.

Throughout the 1990s and beyond, the International Labour Organisation (ILO) routinely reported on what it described as the "widespread and systematic" use of forced labour. In response to its critics, the regime dismissed the reports. "The people of Myanmar are enjoying human rights no less than the people of other countries," information minister Kyaw Hsan told the Washington Post. Other officials were more direct. "To say this is a government policy," one Burmese diplomat said in an interview, "is bullshit."

Despite the changes that began in 2010, the ILO has reported there has been "no substantive progress" towards ending forced labour. By August the following year, information minister Kyaw Hsan said Burma was "almost free from forced labour." Two months later, the ILO said that forced labour complaints had increased to an average of 30 a month.

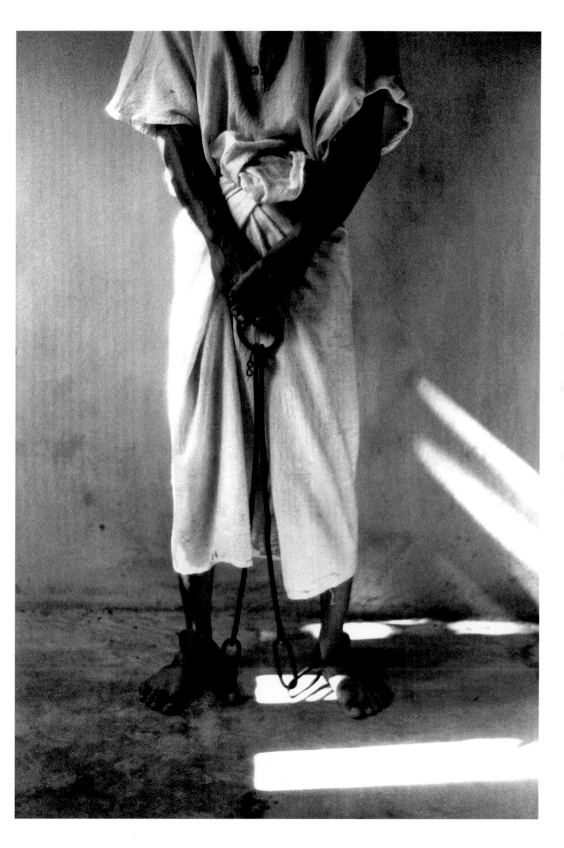

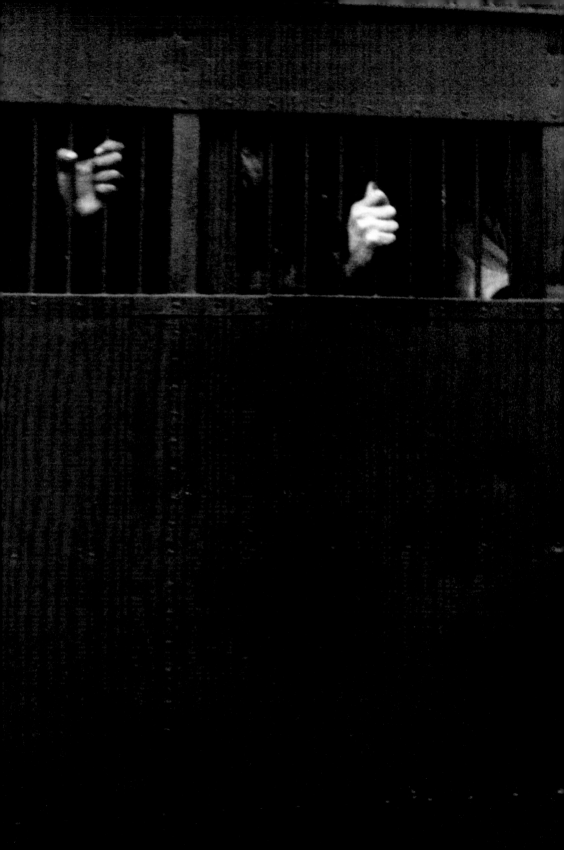

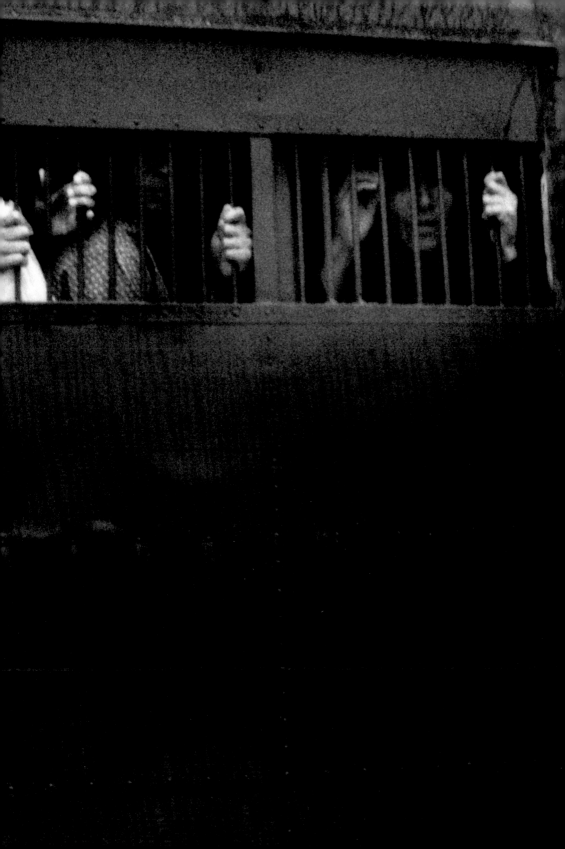

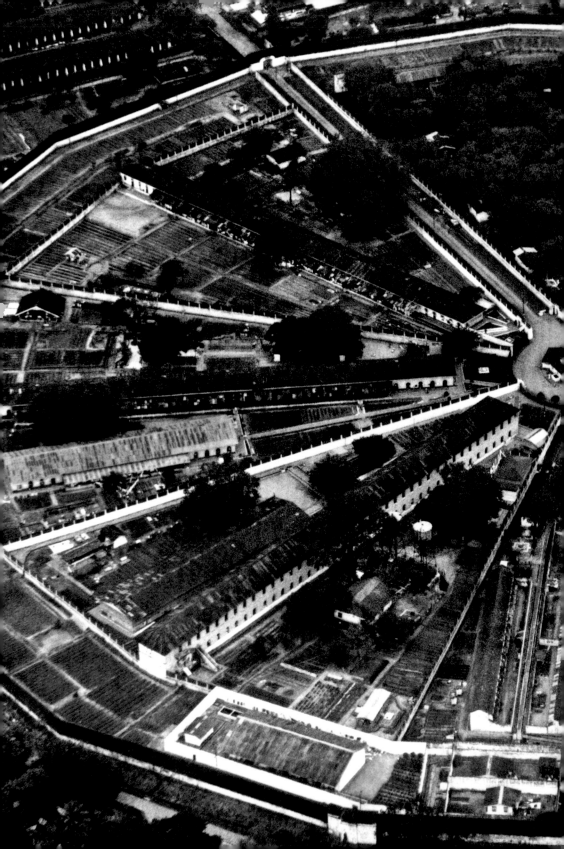

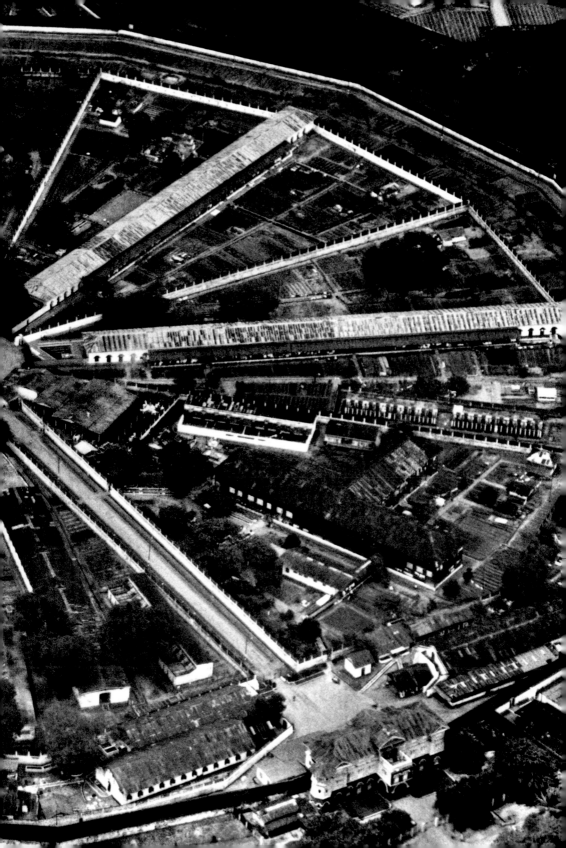

PREVIOUS SPREAD Insein prison in Rangoon.
Built by the British when Burma was ruled as part
of British India, it was the largest penal facility
in the empire. The prison is notorious for its harsh
conditions and the routine use of torture.

Torture is endemic in Burma's prisons and detention
centres. "When we're hooded, that's when we know
we're going to be tortured," said former political
prisoner, Bo Kyi. "It's the worst kind of psychological
torture." The anticipation of violence, he said, is often
worse that the pain itself.

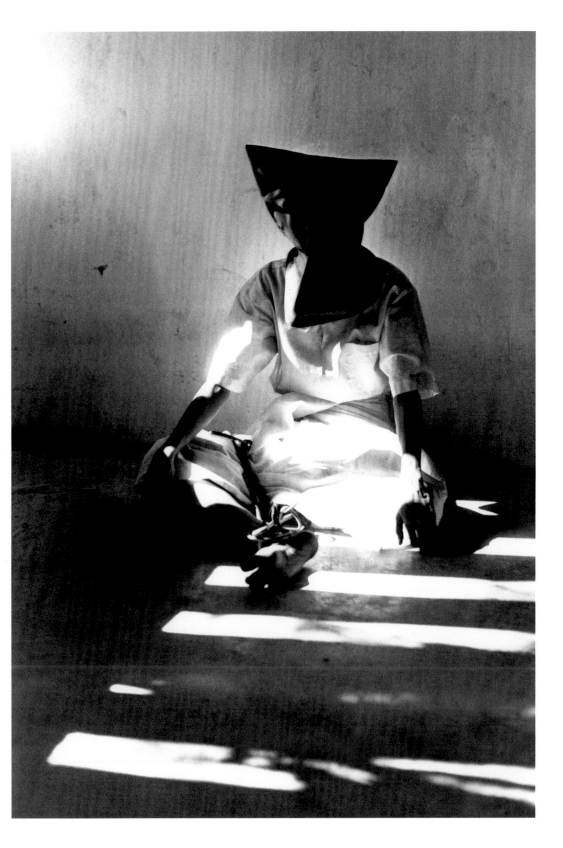

The interrogation position. All prisoners have to learn to adopt poun-zan, or "model", positions in prison. Prisoners are made to sit, squat and stand in the same position for hours on end. When they are unable to hold the position any longer, they are beaten.

OVERLEAF LEFT Roll call.

OVERLEAF RIGHT When a prison warden passes.

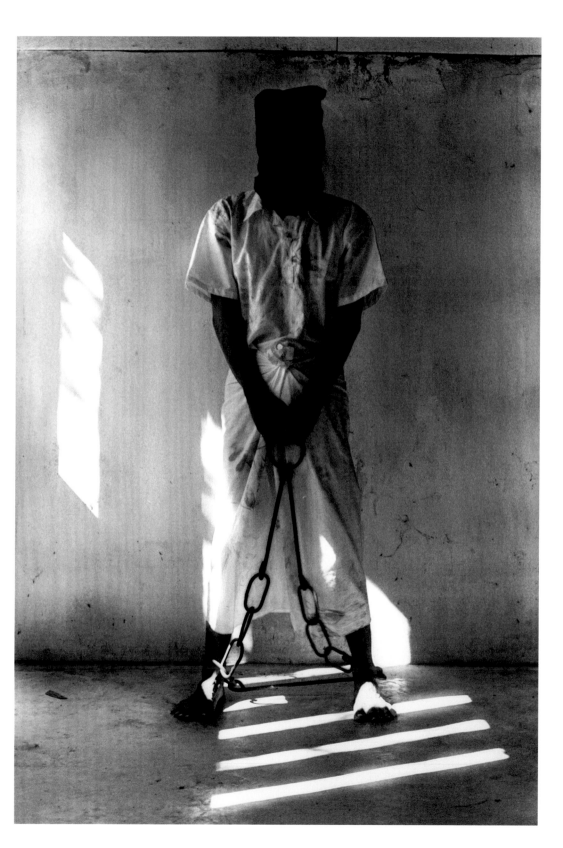

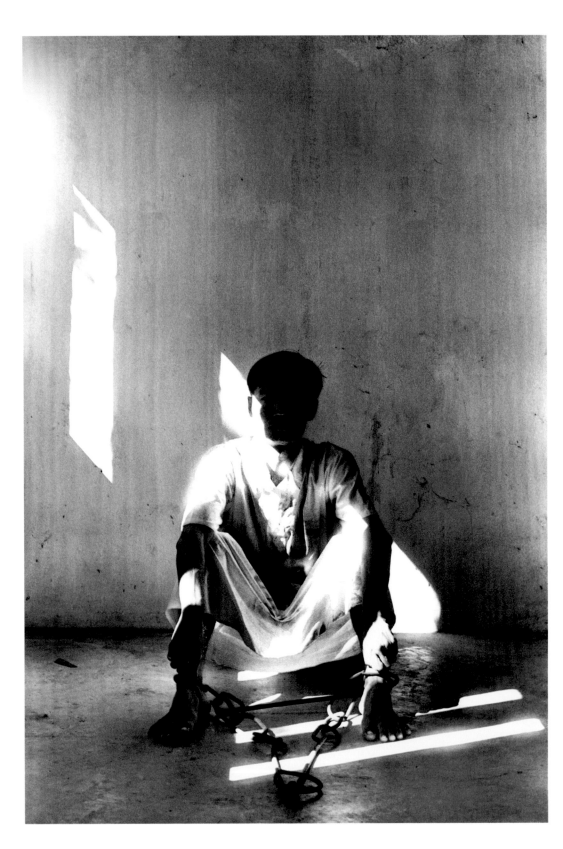

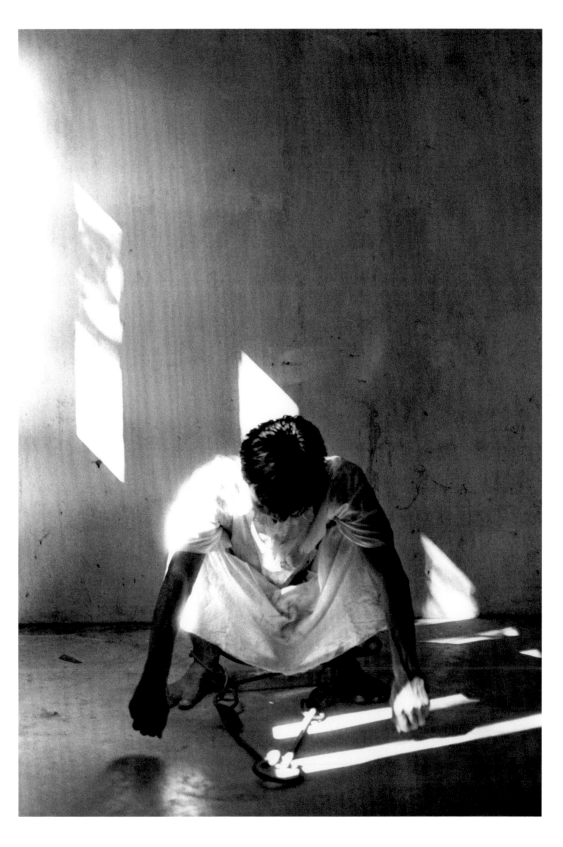

Inspection.

 OVERLEAF LEFT This is a punishment position, where heels are not allowed to touch the ground. Prisoners would typically be forced to hold this pose for one hour in the morning and one hour in the evening. Failure to maintain it would result in a beating.

OVERLEAF RIGHT Punishment position.

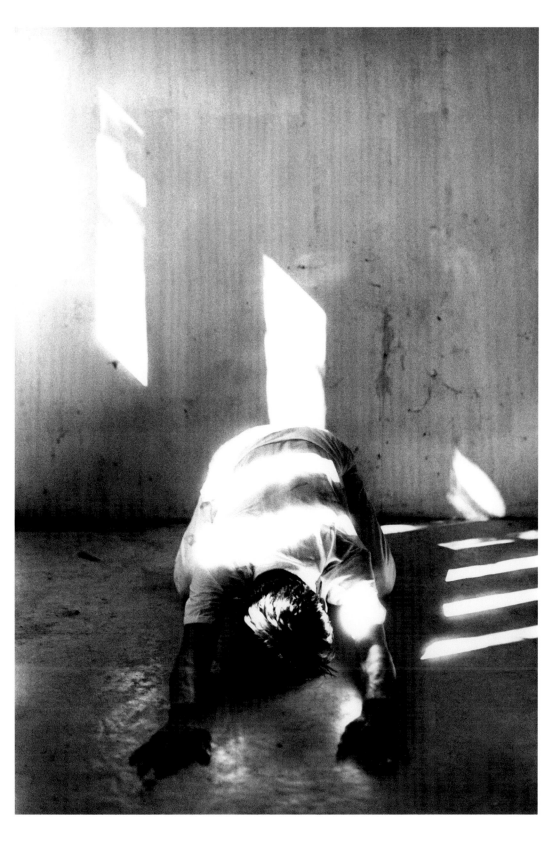

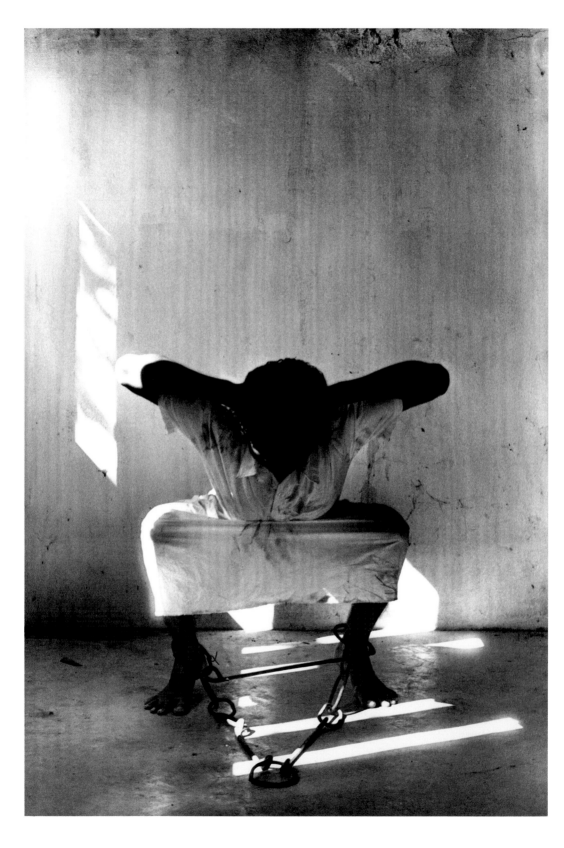

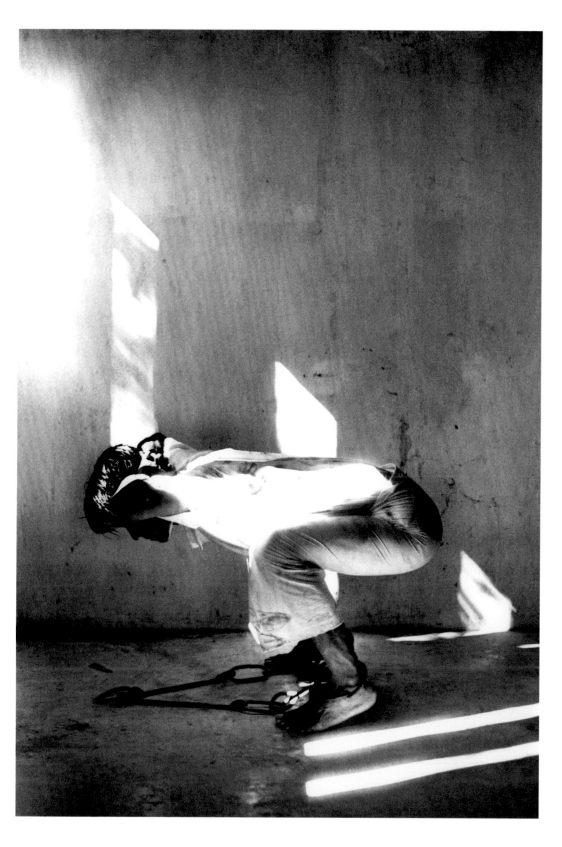

Punishment position. Prisoners would be forced
to balance on elbows and knees only. On occasion,
prisoners would be forced to cross rocky ground.

OVERLEAF Chain gang, 2005. Prisoners work
on land belonging to the ministry of agriculture
in Shan state. The military have also used prisoners
to carry ammunition and supplies to frontline areas.
One prisoner I met had been sent to porter in Karen
state despite completing his sentence. He managed
to escape with two of his comrades who were not
so lucky. They were shot and killed.

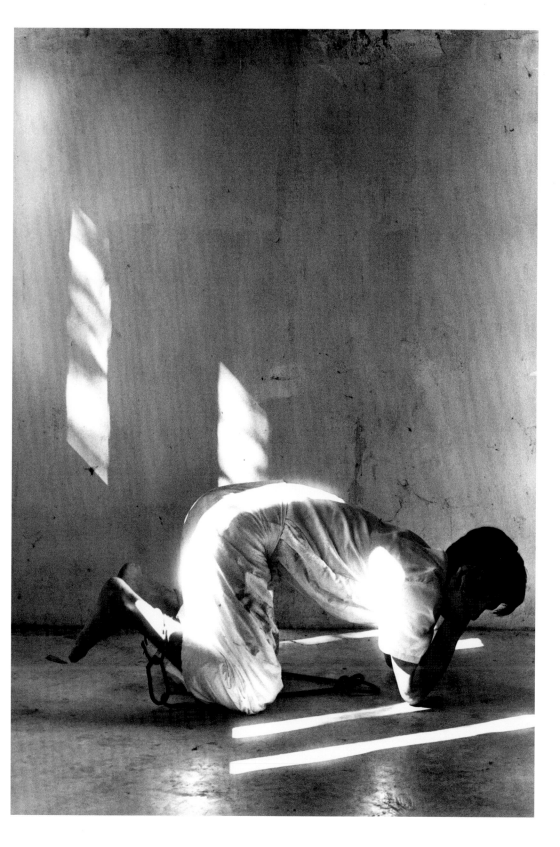

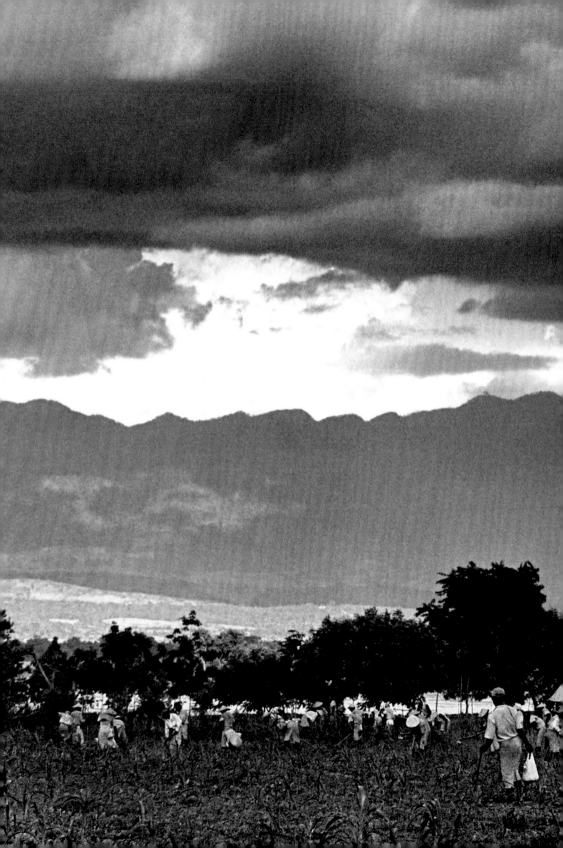

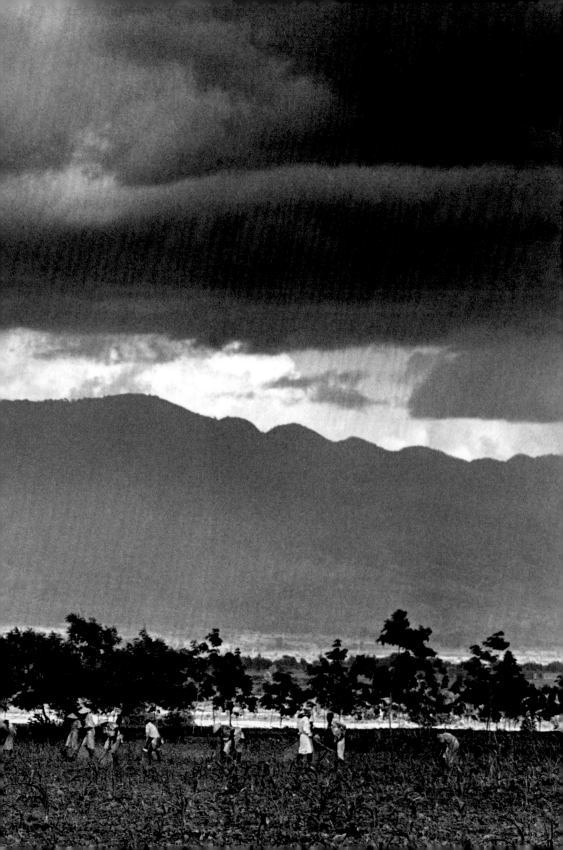

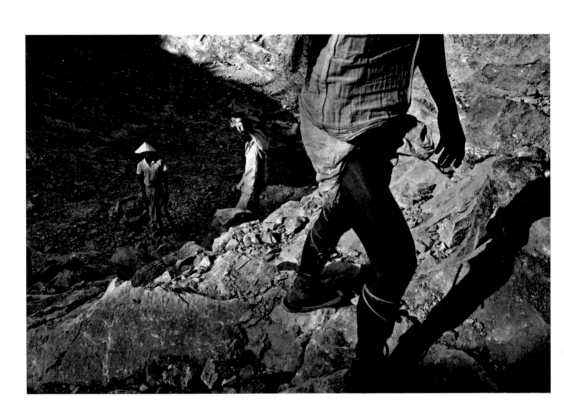

ABOVE AND OPPOSITE Many political prisoners
were sent to labour camps in isolated parts of the
country, far from their families. In places like this,
high on the Shan plateau, temperatures can drop very
low at night. Here, the prisoners worked under armed
guard in a quarry. Because of chains, loose rock and
sheer drops, the work was hard and slow.

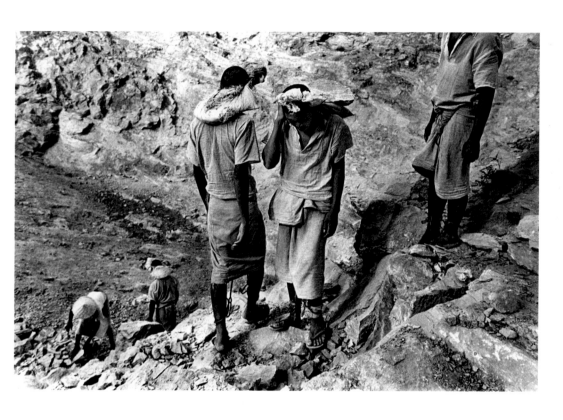

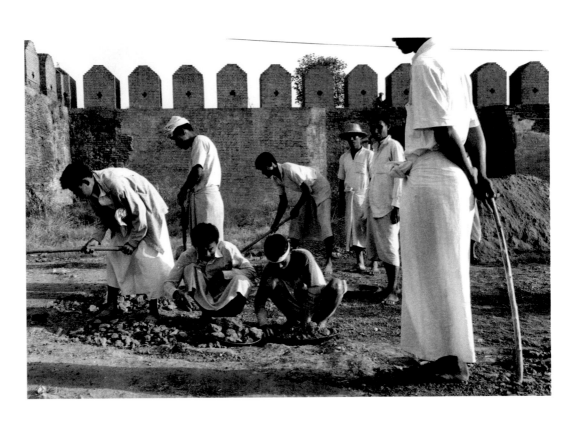

Mandalay, 1995. Prisoners work on a road outside
the palace in preparation for "Visit Myanmar Year",
a tourist drive to attract hard currency and legitimacy.

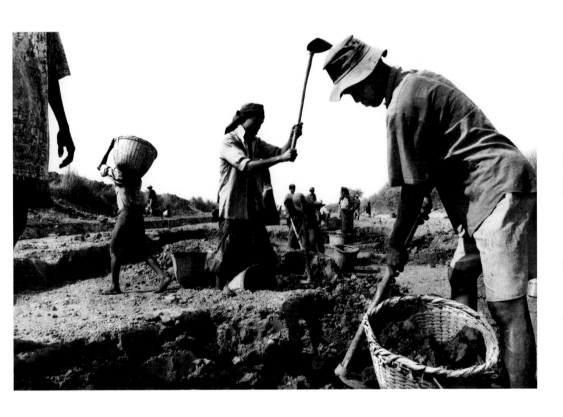

ABOVE AND OVERLEAF Forced labour, Pegu division,
1997. Throughout the country villagers are forced
to work by the military and receive no compensation.
In projects such as this – to widen a canal – entire
families would be forced to contribute labour.
Such is the scale and ubiquitous nature of forced
labour in Burma that there is little need to send police
or troops to watch over the work. With the absence
of uniformed men, there is nothing to indicate that
workers are anything other than paid labourers.

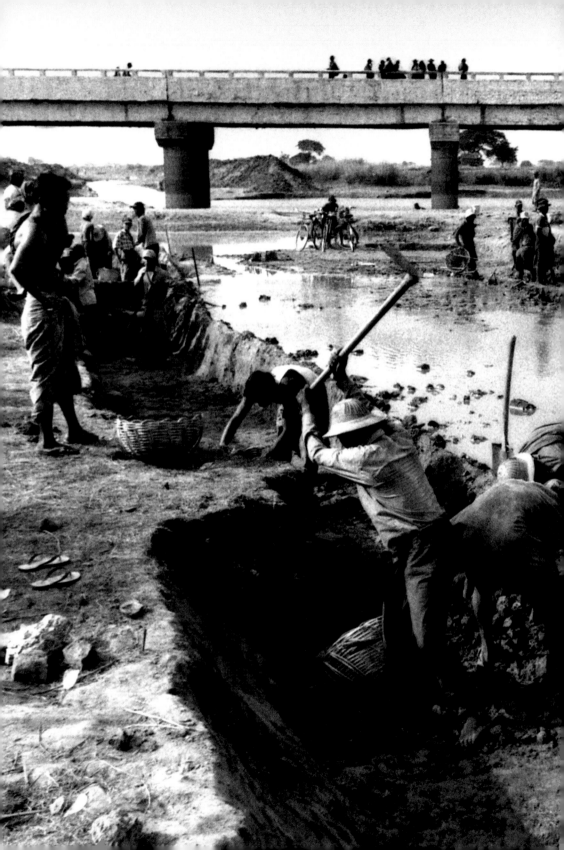

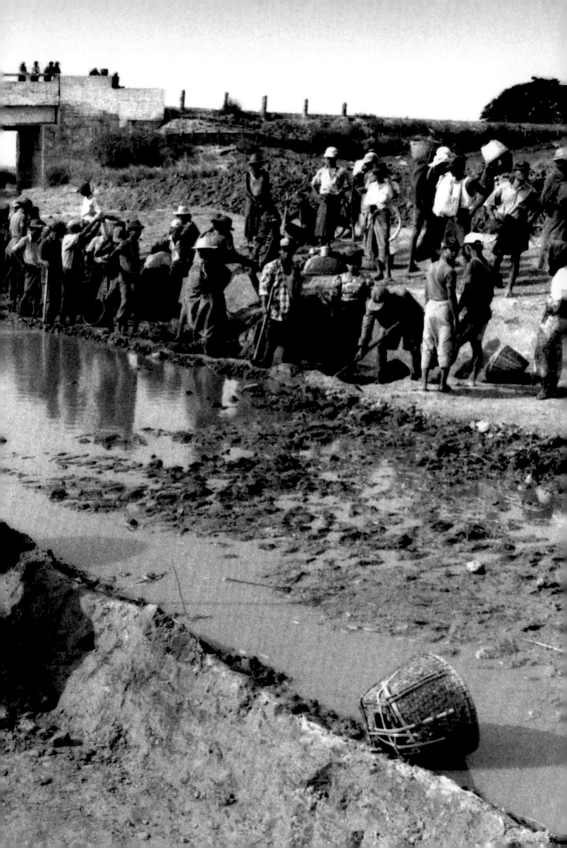

Sittwe, Rakhine state. A boy ferries water in the fish market. Children in Burma are often forced to work out of dire economic necessity, often far from their families. Many come from families who have been forced off their land or who have no land to farm. Others look for work during the dry season when there is no work to be done in the fields.

OVERLEAF Children work on a road-widening project in Pegu Division, central Burma, 1996. During the run up to "Visit Myanmar Year", it was estimated that as many as a million people were dragooned into providing labour to improve the country's depleted infrastructure.

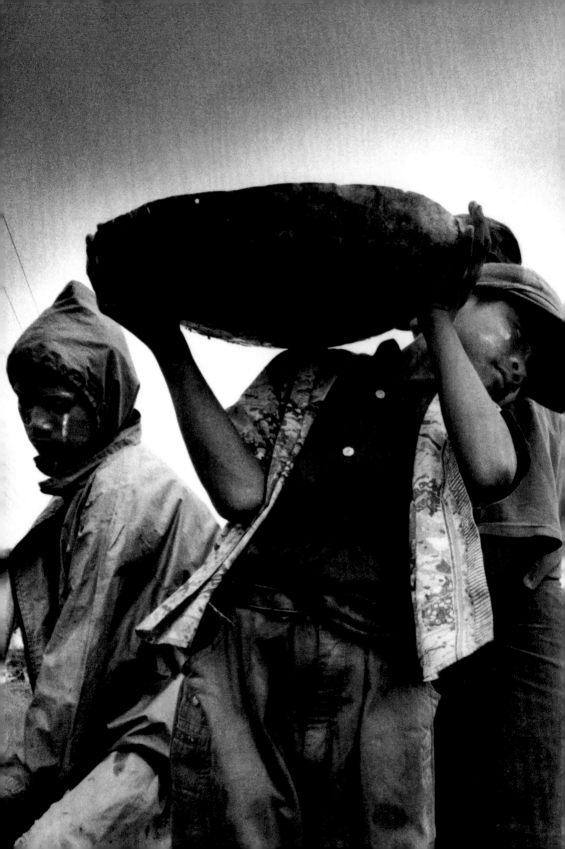

တပ်မတော်
အင်အားရှိမှ တိုင်ပြည်
အင်အားရှိမည်။

ONLY WHEN

THE ARMY IS STRONG WILL

THE NATION BE STRONG

THE ENEMY
WITHIN

The more I travelled inside Burma, the more my curiosity shifted to the secretive military. Little was known about the Tatmadaw beyond condemnation for its abuses and this emphasis on vilification was rarely informative. I wanted to understand something of its world, but taking pictures of the army proved difficult and soldiers were a rare sight. For years, I had to steal photographs of those I did see. Then, suddenly and much to my surprise, I got my chance.

In 2007, I was among a handful of journalists to be invited to the junta's annual military parade in the new capital, Nay Pyi Daw, located in the centre of Burma. Within days, I found myself surrounded by thousands of soldiers and I was permitted to photograph them at will.

It was the first time the outside world had been granted a glimpse of the city the generals had built. Set in the middle of malarial scrubland 300 miles north of Rangoon, Nay Pyi Daw ("Seat of Kings") is a strange, gleaming collection of official hotels, ministries and government housing. The regime spent billions of dollars building this largely empty metropolis in one of the poorest countries in Asia. Despite chronic power shortages that leave much of the country in regular blackout, the new capital gleams with 24-hour electricity.

The move was sudden. On November 6, 2005, at precisely 6.37am, a large convoy of trucks began transferring government workers from Rangoon to the new site. The junta offered little explanation. "Due to changed circumstances, in which Myanmar is trying to develop a modern nation, a more centrally located government seat has become a necessity," it said in a statement.

The creation of a new capital has been the subject of much speculation in this secretive state. One theory is the junta's fear of invasion by the United States, particularly in the wake of Afghanistan and Iraq. For years, the US and other Western governments criticised the regime's human rights record, imposing economic sanctions. Almost a year before the move to the new capital, the US included Burma in a list of "outposts of tyranny", along with North Korea.

Many believe the decision was simply strategic. Located in the centre of the country, Nay Pyi Daw is adjacent to other parts where insurgents operate. A stronger military presence here would put the regime in a better position to defend itself against both internal opponents and foreign invasion. As the ruling military clique has a background in jungle warfare and knows little of the outside world, the move reflected a siege-like mentality.

But there were other, less rational reasons for shifting the capital. For the people of Burma, numerology and astrology are an important part of life. The moment chosen for independence from the British – 4.20am – had followed astrological dictates. The 1988 general strike began on the eighth day of the eighth month, 1988. Five days after the first convoy left for the new capital, at 11am, a second convoy departed, comprising 1,100 military trucks of 11 military battalions and 11 government ministries. The move took place on the 45th anniversary

of the military takeover of Burma (four plus five equals nine).

The generals on Armed Forces Day, 2007.

For General Ne Win, the former Burmese dictator, the number nine was all-powerful, as were its multiples and sums. When he demonetised the Burmese currency, he introduced the awkward 45 and 90 kyat denominations. Armed Forces Day continues to be held on the 27th day of the third month of the year (two plus seven equals nine). The year I visited it was a rounded 27/3/2007. In the junta's new citadel, I began to see the number nine everywhere.

My hotel was a high-class collection of bungalows overlooking a man-made lake surrounded by wasteland. An emerald carpet of grass swept down to the water and newly planted palm trees dotted the area, still propped up by frames. In the distance, I could make out new buildings that danced and shimmered in the heat haze. The rooms were palatial, with air conditioning, silk pillows and antique furniture. An enormous television sat in a cabinet where, to my surprise, I could watch Al Jazeera, BBC World and CNN.

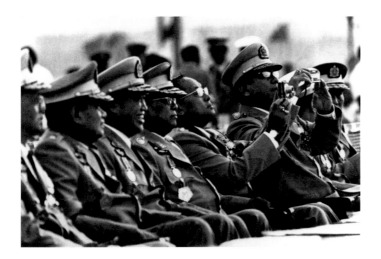

The press conference was held at the ministry of information. It was a featureless block with a large conference room, where state-sponsored media milled around uniformed officers of the Tatmadaw, together with government officials in civilian clothing. Next to their smart, traditional dress, the handful of foreign press looked positively scruffy. There were displays on the walls for our benefit, which presented images of well-run Burmese schools, prisons, AIDS prevention schemes and drug eradication programmes.

The conference was opened by the minister of information, Brigadier General Kyaw Hsan, a small, bespectacled man in a shiny green uniform. The conference consisted of numerous "clarifications" and presentations of the "true situation". It was a crude public relations exercise and went on for hours. The rigid tedium and humourless formality of the event was written even on the minister's face. By the time questions came, it was clear that no one was going to talk off-script and there seemed little point in asking anything. The answers that came were

long and rambling. Unpleasant questions were ignored.

After the press conference, I drove around Nay Pyi Daw. Soldiers appeared out of nowhere to prevent me from photographing a deserted roundabout. A camera crew was stopped from filming when they talked to a group of workers on the road. Everywhere, vast structures were emerging from the scrub. My driver wouldn't let me take pictures in certain quarters of the capital for fear he might be arrested.

The following morning, on Armed Forces Day itself, we were driven in a convoy of flashing cars to the parade ground. People were forced to stop on the road to let us pass. It was strange to see Burma from the other side of the looking glass. Then I found myself among the generals themselves. They looked so ordinary, snapping pictures of their troops with small digital cameras. They paid scant attention to their foreign guests.

The parade ground was vast. Beneath statues of old Burmese kings, 15,000

soldiers marched in their polished boots, their bayonets gleaming in the early morning sun. The statues depicted Anawrahta, Bayint Naung and Alaungpaya: warrior-leaders celebrated for uniting their kingdoms. In the minds of the generals, they represented a glorious time before Burma's humiliation by the British who, in 1885, put an end to centuries of royal rule and marched the last king off to exile.

The media were allocated a spot beside the generals. It was not ideal – potted plants got in the way and the soldiers were on the far side, dwarfed by the scale of the parade ground. The colossal figures of the kings looked down upon a Lilliputian army.

I noticed a cluster of soldiers ahead of us who were clearly observers and nearer to the troops. I asked my minder if I could stand closer and, to my surprise, he agreed. They took me to the spot and I got my photographs of the mighty Burmese army. United, disciplined, tough and monolithic: this

was how they wanted to be seen. Ironically, it was also how they were viewed by the outside world.

There was silence as they waited for Than Shwe, their supreme commander, to arrive. A gleaming black Mercedes drove up and, out of the sun roof, emerged the head and shoulders of Burma's dictator. He didn't move and looked directly ahead. I was reminded of El Cid fastened to his horse to lead his army into battle.

Than Shwe took to the podium and stood in the morning sun, flanked by officers with swords. Without faltering, he delivered a speech rebuking countries such as the US. He showed few signs of his reported ill-health. "Judging from the lessons of history," he said, "it is certain that powerful countries wishing to impose their influence on our nation will make any attempt to undermine national unity." He went on to remind his troops of how the British had practised a divide-and-rule policy among ethnic groups and likened the outbreak of hostilities within the country to "unfastened bamboo poles falling apart". He ended his speech with a vow to crush "internal and external destructive elements obstructing the stability and development of the state" – the sincerity of which he would demonstrate six months later.

His speech over, General Than Shwe left the podium and inspected the army from his sun roof. Then he was driven out of the parade ground, followed by the generals in their cars and the troops on foot. I and my fellow journalists were whisked away on a whirlwind tour of the capital.

Not long afterwards, in September 2007, thousands of peaceful protesters, led by Buddhist monks, took to the streets of Rangoon in a display of defiance. The protests were dealt with swiftly and violently. Scenes of armed police crushing the protests were broadcast globally. More than 100 people were killed and thousands arrested. Any outsiders who thought the regime would falter when confronted by monks were badly mistaken. The world reacted with moral indignation. "Americans are outraged by the situation in Burma," President Bush declared. He then announced new sanctions against the junta, calling Burma's regime "illegitimate and repressive".

Then the country was hit by cyclone Nargis and the Irrawaddy Delta was devastated, but still the military remained in control. Each time I applied for a visa after that, it was refused. Six months later, on the next Armed Forces Day, Than Shwe celebrated the military's 46th year in power.

Armed Forces Day is considered the birthday of the modern Burmese army. And, with a proud warrior heritage, it is no accident that Burma's national hero was a soldier.

Before Japan invaded Burma in 1941, Aung San reached out to the Japanese, believing they would help deliver independence from the British. Later, when it became clear that the Japanese had no intention of granting independence, Aung San and his men turned against his former allies and joined the British.

It was Aung San who later negotiated Burma's independence. Just before it was granted, in 1947, he was assassinated, along with most of his cabinet.

His memory is revered by many today. During the uprising of 1988, his portrait was carried by protesters through the streets. When his daughter became the figurehead of the protest movement, she reminded the generals that her father believed the military had no business in politics. Then Aung San's portrait, which used to hang in homes and shops, gradually disappeared from view and bank notes no longer carried his image.

The army's organisational structure and command style can be traced back to the Japanese Imperial army, which trained the founders of the Tatmadaw. Many of these generals, including Ne Win, held active posts until the 1970s. Like the Japanese Imperial army, the Burmese military relies on a highly centralised control structure and rigid discipline. Ne Win's "four cuts" policy, introduced in the late 1960s, also bore a striking resemblance to the Japanese army's "three all" policy in China: kill all, burn all, destroy all. An absolute obedience to orders has contrasted with impunity in the field, where atrocities have been routinely committed. As one general remarked, "our Tatmadaw was made in Japan."

Ne Win was also trained by the Japanese secret police and it is likely his intelligence apparatus was based on the Japanese imperial model, the Kempeitai. In order to ensure total compliance, the ranks of the armed forces were peppered with informants and spies, rendering dissent virtually impossible.

It is this strict and unquestioning approach to orders, emerging from a deeply conservative society, which has contributed to military domination for so long.

Although evidence of army brutality is overwhelming, abuse has not been the sole domain of the Tatmadaw. Other ethnic armies have been known to abuse civilians and prisoners too. In 2001, Shan troops attacked a Burmese outpost on the border with Thailand. The Thai press were tipped off and watched from a safe distance as the Shan burned the camp to the ground. They captured a number of Burmese soldiers and, having told the Thai press to put their cameras down, slit the throats of their prisoners. Almost a decade earlier, in Kachin state, members of the All Burma Students Democratic Front tortured and murdered members of their own ranks suspected of being spies. The closer one looks, the distinction between perpetrator and victim, freedom fighter and oppressor becomes more blurred. Nevertheless, it is at the hands of the Tatmadaw that the majority of abuses have been carried out.

When the British ruled Burma, the army was mostly Indian. But minority groups, such as the Kachin and Karen, were also recruited. The British considered these ethnic peoples more "martial" than the Burmans. This was an insult to the Burmans' proud warrior heritage. During the Second World War, while the Burmans joined the Japanese, many ethnic groups sided with the British. As a result, there were several reprisal massacres of ethnic Karen. The fact that many ethnic groups were also Christian, unlike the Buddhist Burmans, fuelled resentments that have continued to this day.

After the war, Burma was in ruins. The country was awash with arms becoming one of the most militarised societies in the world and faced with a daunting number of insurgencies. For a time, Mandalay city was occupied by both the Karen and the Burmese communist party. The communists were well armed and had the potential backing of China. It looked as though the country might collapse. The Burmese military believed that only a strong army could hold the country together. Over time, the various insurgencies were pushed back to the mountains and forested borders. This fear of fragmentation provided justification for the military's continued hold on power and the army became a state-within-a-state, an insular society in which military men dominated the economy and every other sphere of Burmese life.

There is a saying in Burma that the only colours on state-run television are green and orange: green meaning the military, orange the monks. The population has long been bombarded with images of generals kneeling in front of impassive

Armed Forces Day, 2007. Lt. Gen Aung Htwe (centre) was then commander of the Bureau of Special Operations in Karenni and Shan states, where abuse of civilians was routinely reported, including portering, forced labour, torture, rape and murder.

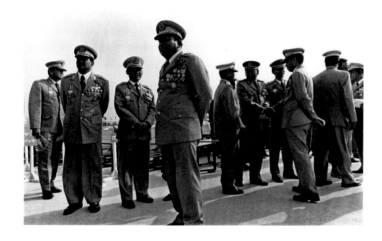

monks, handing over alms in the form of hampers of soap, biscuits, silk robes and other goodies. This is what passed for news. Giving alms was one way the generals could demonstrate their good Buddhist credentials and, by extension, legitimise their place at the head of the country. As one former soldier put it: "In Burma, it is Buddhism which has most influence culturally. If the generals are rich, people believe they must have done good in their former lives. This kind of thinking keeps the people from trying to change things. It's guns and religion that hold people down."

While reforms take place in Burma, the military remains virtually untouched. For years, the generals had little concept of the world beyond the country's borders: of economics, of the internet, of global markets. This is an army that has been reared on "internal and external threats", on long experience of jungle warfare and a self-imposed isolation. When a highly educated woman talks to them of democratic and human rights, it is not a language they understand.

The first time I met Burmese troops was in 1992. I was travelling through insurgent territory near the Thai-Burma border controlled by the Karen National Liberation Army, which was fighting for an independent state. A group of young men and boys were marched out in front of me, all conscripts who had allegedly participated in atrocities before being captured during a battle. They had malaria and some were suffering from beriberi. Terrified and visibly malnourished,they were a pitiful sight.

Despite massive amounts of military spending in Burma, soldiers of the lower ranks are poorly resourced and have often been forcibly recruited and brutalised in the frontlines of the civil war. The lower ranks are comprised of many ethnic nationalities, but there is a ceiling of promotion within the armed forces and the officer class is reserved almost exclusively for the Burman majority.

I got my first photographs of soldiers on the frontline at an army encampment in the north east, a lonely spot which, several years earlier, had been attacked by insurgents and burned to the ground. The portly commander was clearly bored and welcomed the novelty of having a foreign visitor. He and his lieutenant treated me to rice wine and deep-fried bat before taking me on a tour of the camp. But he warned me: I could only take photos of the men if they were not in uniform. He held his fists together as if cuffed, telling me that if they (Military Intelligence) identified the unit, he would go to prison.

It wasn't hard to follow his instructions – most of his men wore sarongs and T-shirts. They looked more like a ragtag militia than members of a totalitarian army. Tough-looking farmers' sons, they reminded me of the Khmer Rouge rank and file I had met in Cambodia. The commander and his lieutenant were ethnic Burman; the rest were Rahkine, Karen and Mon.

This domination of the officer class is a source of resentment. Morale among lower ranks remains low and desertion is reportedly high. The reality of the Burmese army is a far cry from the parade ground image of Nay Pyi Daw.

MYO MYINT

Myo Myint was 17 when he joined the Burmese army. After training as an engineer he was attached to a light infantry battalion and sent to the frontline in northern Shan state in 1979. There, the Tatmadaw was fighting against the Kachin Independence Army and communist insurgents. His story of life on the frontlines of the civil war is typical of the behaviour of frontline troops.

"One day we needed some people to carry equipment, so we went into a village nearby. All the young men had fled when they heard that soldiers were coming. The only people left were children, women and old people. We took about 40 women as porters. The women were crying. They had been threatened – 'If you don't come and carry our stuff, we'll kill you' – that sort of thing. They were ordered to carry 75mm shells, which are very heavy. They

were aching and, at night, we stopped. One woman was really pretty, about 30 years old. It started with the platoon officer. He held a gun to her head and raped her. Then he said to the rest of the group: 'Do what you like, then get rid of her.' Three other soldiers raped her all night. In the morning, they took her farther away from the rest of the group; then there were three gun shots.

"It's normal to do that kind of thing to ethnic-minority women. For soldiers on the frontline, it's as normal as eating and drinking.

"Each soldier probably carries more than 400 rounds and he can't manage to carry that much himself. So they need to take porters. When there is fighting and they suspect there are minefields, they force the porters out in front. The soldiers threaten to shoot them if they don't go forward. They become human minesweepers."

One day, Myo Myint's infantry unit captured some prisoners.

"They weren't soldiers for the Kachin themselves, but when Kachin troops

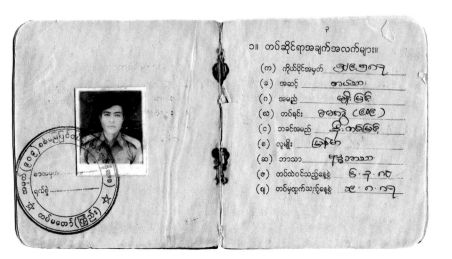

came into their village they would help them, because they had to. If they didn't give them what they wanted, they might be killed.

"But our officers felt sure they were soldiers themselves. One officer took the bayonet from his gun and stabbed one of them in the cheek – it went in as far as his teeth. Then they took a candle and poured hot wax from the candle into his eye. He was screaming in pain. The villagers continued to deny the charges. So they were tortured for a whole day.

"There was no policy for prisoners of war in the Burmese army. We could do anything to them.

"One of the officers came to me and asked about the mines. I pointed out the two fields that had been laid. Then I went to bed. At about 3am I was woken by explosions. I was told that the four prisoners had tried to escape by running through the minefields. Those mines were the ones I had laid.

"Ever since I was a child, I wanted to be a soldier. When soldiers returned

from the front, people treated them with great pride and respect. At that time, people really believed that the soldiers were defending their country. I wanted to be just like them.

"My father was in the medical corps and had never been in battle. I saw officers of higher rank give him orders, sometimes to buy a skirt for an officer's wife [in Burma it is considered humiliating for a man to have to carry a woman's clothing] and whatever he was told to do, he had to do it. I knew there was a lot of difference between officers and other ranks. I wanted to be an officer. If you have money, you can buy power; if you have power, you can take money. As an officer, people respected you. But back then, when I was at school, I didn't know the difference between people showing respect and people acting out of fear.

"At school, we learned to show respect, to be loyal to the elders, like slaves are loyal to their lords. I wasn't happy at school and I started bunking off."

Myo Myint did not pass his exams to be an officer but believed he could work his way up after joining as a private.

"It's really difficult to a get job without investment or family connections. So entering the military is the easiest way. There was a lot of unemployment at the time and only the sons and daughters of army officers could get good jobs."

After joining in 1979, he was sent for training in Pin Oo Lwin.

"Every soldier had to do ideological training for three months. We learned all about policies towards the ethnic minorities, the principles of the Union and how the army is responsible for ensuring the country doesn't disintegrate. They wanted to make sure that this message was clear in the head of every soldier. And every soldier believes this. There were slogans like, 'The Tatmadaw is your mother and your father' and 'If the Tatmadaw is strong, the country will be strong.' The main objective was for each soldier to be completely loyal to the Tatmadaw. We accepted everything we were told. But when we went to the frontline, things were very different. It was nothing like the theory we learned in training. I saw a lot of torture.

"But you can't talk about these things because, even in the Tatmadaw, Military Intelligence is always there. No one knows who is a member of Military Intelligence, so no one dares to talk about these things. Fear is what runs from the bottom to the top of the military."

At the age of 25, Myo Myint was injured in battle. He lost an arm, a leg and several fingers. He was discharged with a small pension and returned to live with his family in Rangoon. He became depressed and began drinking.

"I came to realise that only if there is peace in our country will this suffering end. So I began to wonder what was needed to bring peace."

He began reading up on Burmese history, sometimes by obtaining banned books. He reached out to insurgent groups and, in 1988, joined the protests in Rangoon. After listening to Aung San Suu Kyi speak at the Shwedagon pagoda, he joined her party.

In 1988, Myo Myint attended a rally outside a military base near his home.

"The soldiers were standing like armed guards, with their guns raised.

Students, writers and others were making speeches. And a friend said, 'Why don't you talk?' They had been talking about democracy for too long and people's ears were full of it. But I wanted to talk about the civil war and convince the soldiers to stop fighting. There were about 7,000 to 8,000 people there when I got on the podium. When I got up with my crutches, they went quiet. Then I started to talk. 'Why are we at war? What is peace? What is a soldier's responsibility?' I talked about the need for soldiers to join hands with the people. The next day, about four or five soldiers in civilian clothes came to see me and said they wanted to join the demonstrations. The people were happy to have soldiers join them. Most were demonstrating in their uniform; they didn't change into civilian clothes. At first there were over 100 soldiers. Each day after that, four or five would join in. And it grew to about 200 soldiers."

Eventually, Myo Myint was arrested by Military Intelligence and taken for interrogation.

"They stripped me naked, punched me and beat me. 'You motherfucker!' they screamed, 'you're a former soldier! Why are you turning people against the army?' Then they put me inside a plastic bin and very slowly filled it up with water. When it reached my neck, I wriggled as much as I could and made the bucket fall over with me inside. Being at the frontline is nothing compared to the terror of being interrogated."

Myo Myint was transferred to several prisons, including Insein, and served a total of 15 years. He was never charged. On his release, he left Burma for Thailand, where he worked with former political prisoners in exile. Then he was interred in Umpiem Mai refugee camp before being granted asylum in the United States. In 2008, he was reunited with his brother and sister in Fort Wayne, Indiana.

"Nowadays, I often have nightmares and flashbacks – at least three or four times a week. I often think of the abuses I witnessed, because I feel guilty. I feel responsible for all these things, even though I never took part."

The face of the Tatmadaw. A soldier at the Shwedagon pagoda, Rangoon.

OVERLEAF Power without glory: Burma is home to one of Asia's largest standing armies. This enormous military parade in the new capital of Nay Pyi Daw is an annual event that commemorates the birth of the modern Burmese army in 1945; 15,000 troops marched in a vast parade ground beneath the statues of antique Burmese kings.

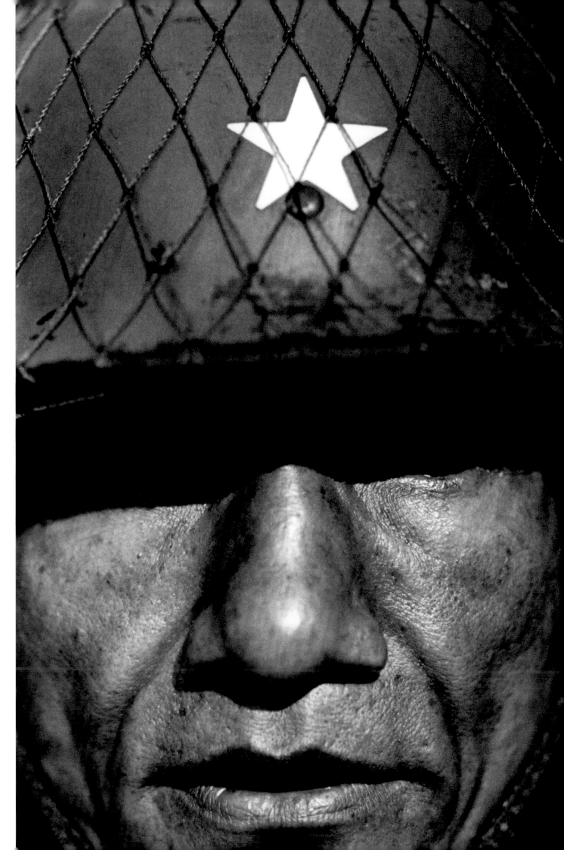

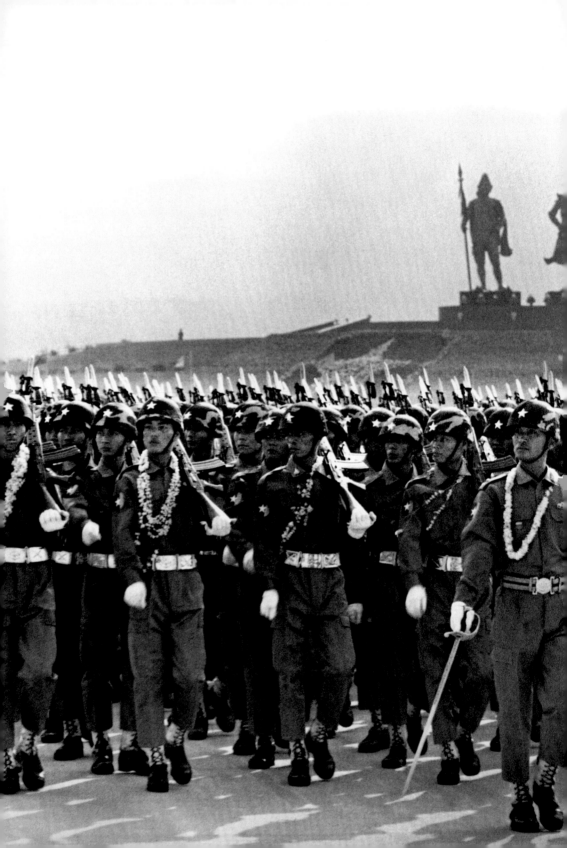

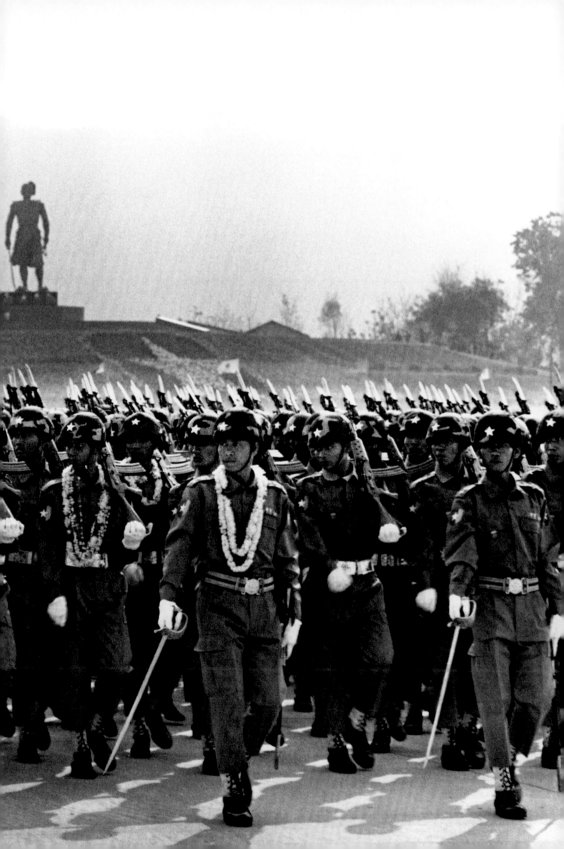

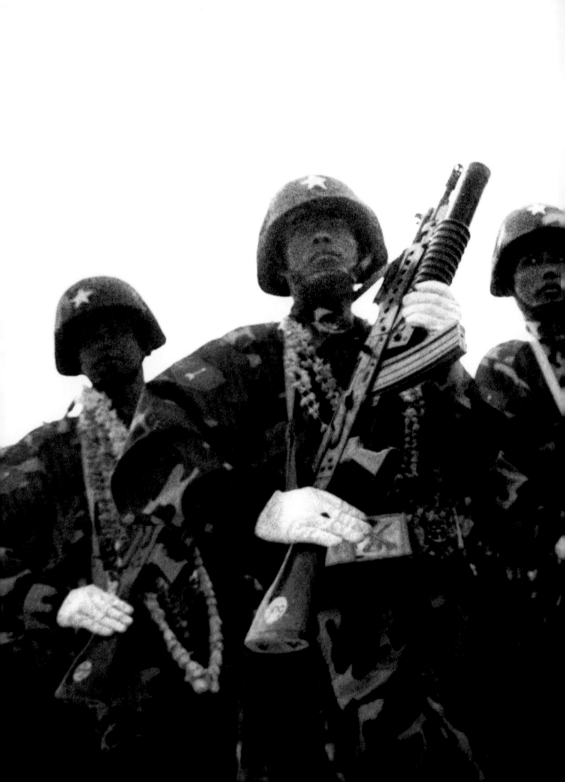

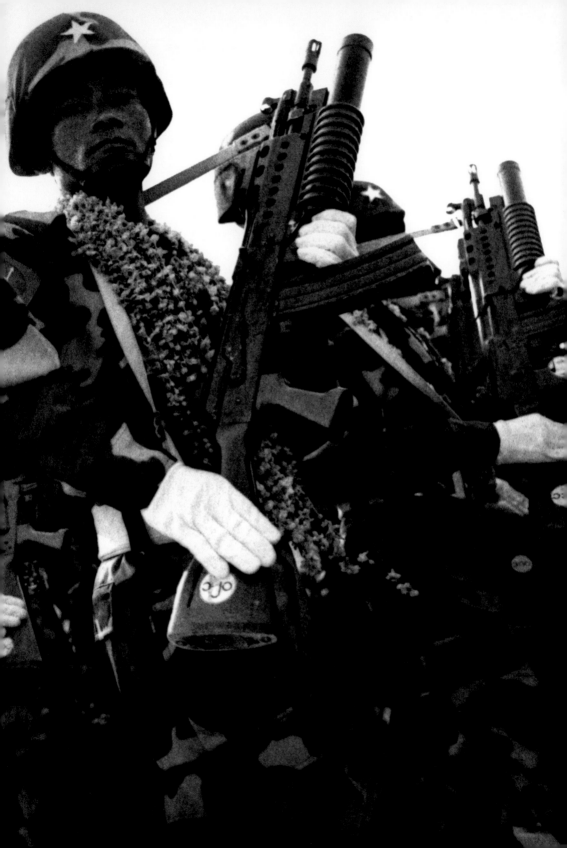

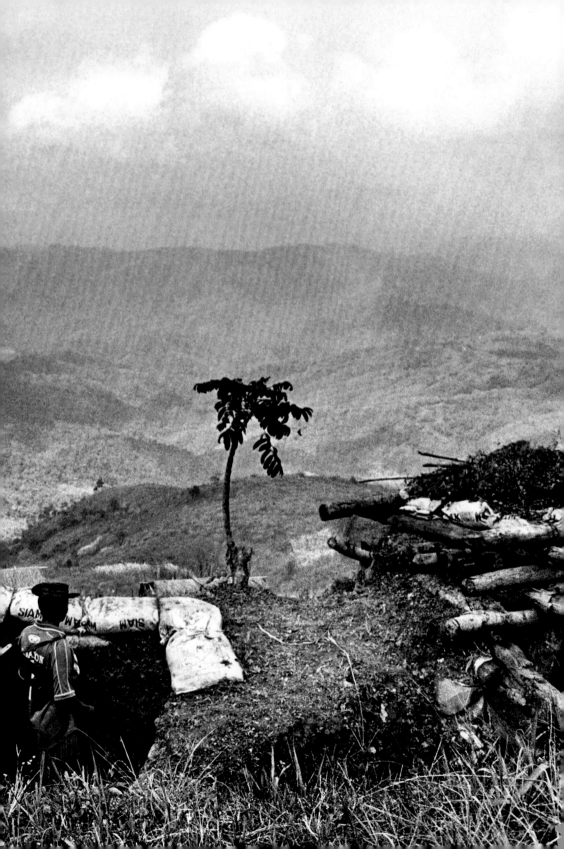

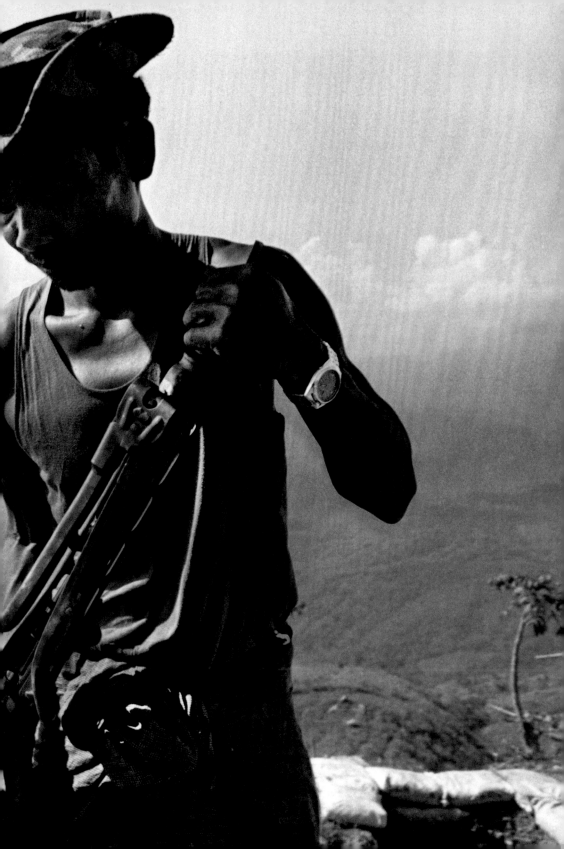

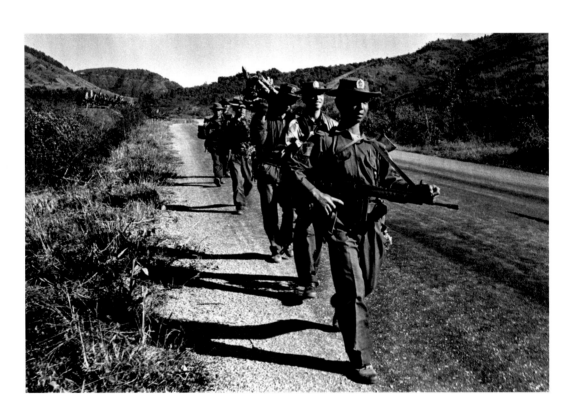

PREVIOUS SPREADS The frontline: a Burmese
outpost in Shan state, 2005. This position was
overrun by Shan State Army troops. They captured
several Burmese soldiers and then executed them.

The Tatmadaw on the move. A Burmese army patrol on
the road to Kengtung in Shan state, in the infamous
"Golden Triangle", a drug-producing area spread
across Burma, Laos and northern Thailand. This
road was allegedly built with drug money.

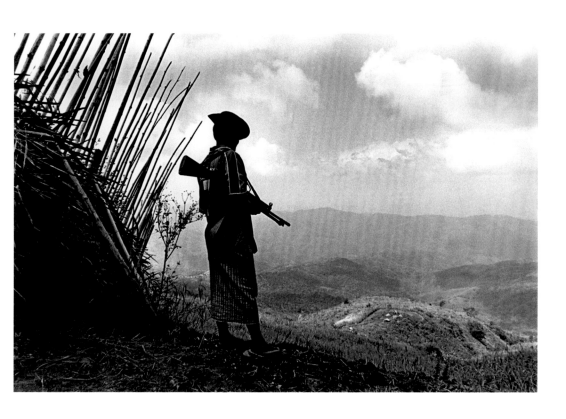

An ethnic Rakhine soldier of the Tatmadaw outside
his hilltop base in Shan state.

Karen state: Burmese troops captured by the Karen
at the battle of Twepawejo ("Sleeping Dog Mountain")
in 1992. The youngest was 15 and the oldest 23. They
allegedly abused villagers. All sides in the conflict
are reported to have executed prisoners.

OPPOSITE A young Burmese soldier awaits his unit
at a train station in Kachin state, 1998. In 2002, Human
Rights Watch reported that the Burmese army had
the highest number of child soldiers of any army in
the world. Many young boys are forced to join, some
as young as 11. Others join up thinking they can escape
poverty and provide for their families. On occasion,
they are sent with no more than rudimentary training
to the frontline. All the various armies fighting the
Burmese army have used child soldiers. The insurgents
argue that they are fighting for their survival and need
all able-bodied males to defend their homes.

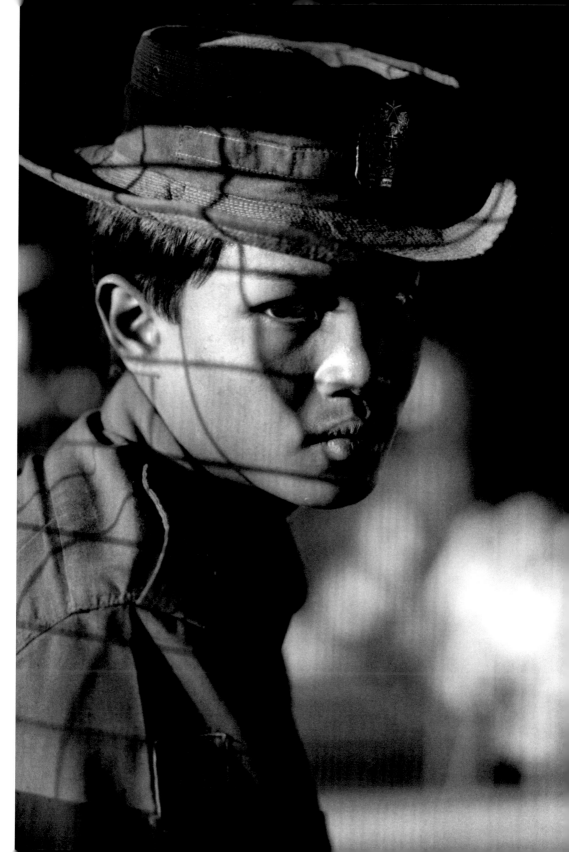

တပ်မတော်သည်
အမျိုးသားရေးကို
�‌ဘယ်တော့မှ
သစ္စာမဖောက်။

THE TATMADAW

SHALL NEVER

BETRAY THE

NATIONAL CAUSE

FREEDOM
FROM FEAR

The only real prison is fear and the only real freedom is freedom from fear.
 Aung San Suu Kyi

After years of disastrous economic policies and sanctions, millions of Burmese have escaped poverty to seek a better life in neighbouring countries. They supply China, Bangladesh, India, Malaysia and Thailand with a constant stream of cheap labour. And they often work in hazardous conditions for little pay. Many are illegal, have no rights and are frequently exploited by corrupt police, officials and businessmen. Women run the risk of being trafficked into prostitution.

In Thailand, there are believed to be at least two million migrant workers from Burma. Although there is a recruitment system that allows them to enter Thailand legally, this system is time-consuming and expensive. As a result, many migrants continue to enter the country through informal and illegal means, sometimes facilitated by brokers. Migrants are often snared into debt bondage, with their wages deducted to pay off the cost of the broker who found them the job. In some cases, workers are never paid and become subject to a modern form of slavery. Violence and harassment are commonplace. On deep-sea fishing boats, where the men are trapped at sea for months at a time, there are reports of beatings and murder.

In Thailand, the Burmese are resented because they are perceived to be taking jobs away from locals. In fact, the reverse is true: jobs left open to migrants are generally shunned by Thai workers because of the low pay and difficult working conditions.

In 2006, I met Rosy and Nadine, young workers from Burma who had found employment in a clothes factory just outside the Thai border town of Mae Sot. We talked in a windowless, concrete room that served as lodging for them and other factory workers, all of whom slept on the bare floor. Neither Rosy nor Nadine had work permits.

They worked in a garment factory. Although the clothing was assembled in Thailand, the material came from China. The labels Nadine and Rosy sewed on to clothes sported the brand names of BCG and the Nike logo. They worked eight-hour days, including Sundays. But if a big order came in, they would have to work until midnight or beyond. They were given one day off a month and, on occasion, some Thai holidays. Most of the workers were between the ages of 18-35, but some were as young as 14. At the time I met them, the minimum wage in Thailand was about $4.60 a day. Nadine and Rosy were paid $1.80.

The lack of any legal status for many Burmese in Thailand enables employers to withdraw or deduct payment, with no recourse available to workers. Police can extort money from them, using the threat of arrest and deportation. When a worker is arrested, unscrupulous factory owners take advantage and refuse to pay outstanding wages. Thai police sometimes work in tandem with owners. Before a raid to catch illegal migrant workers is mounted, the police contact the owner so that he or she can be absent when the raid takes place. Workers can then be arrested and sent back to Burma, having to pay bribes to avoid jail.

At the border, they have to pay a series of fees at various checkpoints before returning by another route to start the process of finding work again.

There are other ways in which Thai factory employers abuse their workers. One time, Nadine fell sick and took five days off to recover while living on factory premises with the other workers. The owner was livid. Even though she was ill, she was made to go back to work. On pay day, she received half of what she was owed.

But it is not only in factories that people seek employment. Many also work in the sex industry. In Ruili, on the old Burma road into China, thousands of migrant women have sought work. They are particularly vulnerable to a range of abuses, disease and drug addiction. In one tenement block I visited, between 20 and 30 people had died in the past two years, most of them from AIDS or overdoses. One had been knifed to death in what was thought to have been a drug dispute. Many of the tenants were sex workers and most were addicted to methamphetamine or heroin.

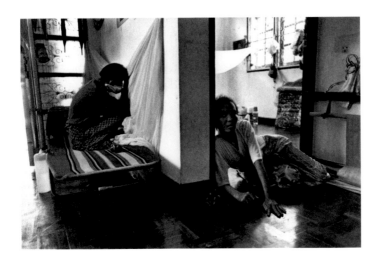

Although I had tried to photograph the health conditions inside Burma, I was forbidden from taking pictures in hospitals. Even if I did obtain access, I risked putting patients and hospitals staff at risk from the authorities, so I turned to clinics on the Thai-Burma border. There, in Mae Sot hospital, I met Cho Cho Win.

CHO CHO WIN

After an abusive home life in poverty-stricken Burma, Cho Cho Win sought work as a domestic servant in neighbouring Thailand. Having safely crossed the border, she managed to organise passage to Bangkok through a broker. She had no passport or documents of any kind. She was escorted by a Thai policeman, who raped her, then delivered her to a brothel for a $500 fee. After a few days, she managed to escape with another woman and returned to the border.

A young girl is treated
for abcesses in Mae Tao
clinic on the Thai border.

She later contracted HIV from her husband. On learning she had been infected, her family abandoned her and she was looked after by a local organisation in Thailand. Unlike the vast majority of AIDS sufferers in Burma, she had access to anti-retroviral drugs. She lived in a shelter in a town on the Thai side of the border with four other Burmese women and their children, all of whom were HIV-positive. Stigmatised by their communities, with nowhere to go, they were given medical and pyschological care as well as bed and board. They were also offered training so that they could then provide trauma counselling to other infected migrants.

At first, Cho Cho Win refused to be photographed. But then she told me she was going to die soon, so it did not matter. Her only condition was that I didn't use her real name; she didn't want to cause trouble for her family in Burma.

Cho Cho Win made regular visits to Mae Sot hospital. While there is a great deal of prejudice against Burmese migrants in Thailand, the staff at Mae Sot

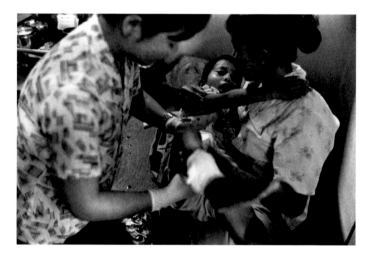

hospital are better informed. More than half the patients are Burmese. Despite the stigma of being an AIDS sufferer, Cho Cho Win said the Thai staff at the hospital were "kind and good natured". She described how they gave her preferential treatment because of her advanced condition, which made it hard to sit down for long periods.

This is not an isolated case. Dr. Ruengweerayut, who was then deputy director of the hospital, believed that everyone has the right to be treated, a view not often shared by Thai patients. Because the staff didn't discriminate, some local people would complain about Burmese being treated there. At times, it could be a source of considerable antagonism.

To those who complained, Dr. Ruengweerayut responded with a simple question: "Imagine if you were the foreigner, how would you feel if we turned you out?"

The deep suspicion between Thailand and Burma is centuries old. For most Thais, the main national reference point is the sacking of the ancient capital

of Ayutthaya by invading Burmese in 1767. The destruction that accompanied the invasion was so total that the city never fully recovered, forcing a new capital to be built in what is present day Bangkok. This traditional antipathy toward the Burmese is nurtured in schools throughout the country. As a result, many Thais distrust the Burmese.

The suspicion goes both ways. Burmese authorities often accuse the Thais of stealing their people for cheap labour. But Dr. Ruengweerayut described how, when staff tried to take wheelchair-bound patients back to Burma, soldiers at the border would refuse them entry, by denying that they were Burmese. Patients would sometimes simply be left in their wheelchairs on the bridge, forcing hospital staff to take them back.

"It doesn't matter to us whether they are legal or not," the doctor told me. "We treat all people, regardless." In Mae Sot hospital, the wards have never been segregated. When there was fighting between Karen insurgents and the Burmese army, the hospital would treat the wounded from both and soldiers from opposite sides would find themselves in beds next to each other. "But we never had a problem," Dr. Ruengweerayut said.

In the 1990s, Burma became a cause célèbre in the West. Not since the days of apartheid in South Africa had there been such interest in a single country. But there was no international consensus about how to effect change. Many, including Aung San Suu Kyi, believed that sanctions would pressure the regime into a dialogue for democratic reform. This resulted in a stalemate, with debates polarised between those who favoured engagement and those who advocated isolating the regime. The combined effects of this stagnation and isolation spilled over Burma's borders to other countries.

Burma's AIDS epidemic is one of the worst in the region. With the years of neglect of Burma's healthcare system, one of the biggest problems for ordinary people is access to adequate medical care. At least one virulent strain of HIV now circulating Asia originated in Burma and, coupled with one of the highest TB rates in the world, contracting the virus is tantamount to a death sentence. In 2005, the Global Fund to Fight AIDS, Tuberculosis, and Malaria withdrew funding worth $100 million. The fund blamed restrictions imposed by the junta. But this withdrawal also came about because of political pressure from activists in the West.

When I learned of the Global Fund withdrawal, I returned to Rangoon to talk to people directly affected. I met U Htein Lin and his wife Daw Khin Khin Maw at a safe house with their two children: six-year-old Phyo Htet Oo and two-year-old Ei Kyu San, all of whom were HIV positive. They were desperate and agreed to be photographed. They also wanted to use their real names. "I don't support sanctions," Htein Lin told me, "because I can't get the medicine I need." Htein Lin had TB and was too ill to work. Khin Khin Maw had sold her shop and her

Cho Cho Win on the Thai-Burma border.

OPPOSITE U Htein Lin with his wife, Daw Khin Khin Maw, their two-year-old daughter, Ei Kyu San, and six-year-old son, Phyo Htet Oo.

mother was selling the family's gold to purchase cheap antibiotics on the black market. Their money was running out.

Several months after I left, Htein Lin was admitted to hospital in Rangoon. It was overflowing with AIDS patients and people were dying all around him. Khin Khin Maw tried to encourage her husband. "He said, 'Don't leave me. I'm scared. I want to hold your hand.' I told him not to worry; in the morning we would go home." When he finally fell asleep, she slept next to him. When she woke up, her husband was dead.

The withdrawal of the Global Fund was literally the final nail in the coffin for thousands of Burmese sufferers. Two years after the withdrawal of the fund, Médecins Sans Frontières reported that 25,000 people had died from AIDS in a single year. Since then, foreign donors, alarmed at the spread of AIDS, tuberculosis and malaria, set up the Three Diseases Fund (3DF) to plug the gap left by the Global Fund. In 2010, the Global Fund approved a new grant of around

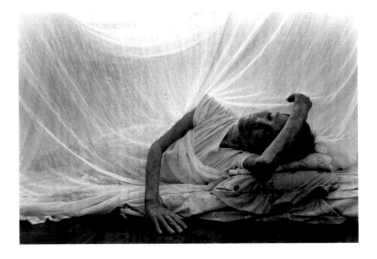

£100 million to promote HIV-AIDS treatment in Burma for a five-year period.

For Htein Lin and Cho Cho Win, this came too late. She died seven months after I took her picture.

The question of whether sanctions work is still a hotly contested issue. With so little leverage in Burma, many pro-democracy activists long demanded international isolation of the regime in order to pressure it for change. But while campaigners all over the world have done a remarkable job of highlighting Burma's crisis, the withdrawal of the Global Fund was seen by some as an example of wrong-headed activism.

As change takes hold in Burma – and the US and EU and others have begun easing sanctions – the AIDS crisis has only worsened. In 2011, the Global Fund cancelled a proposed round of funding due to a lack of international donations.

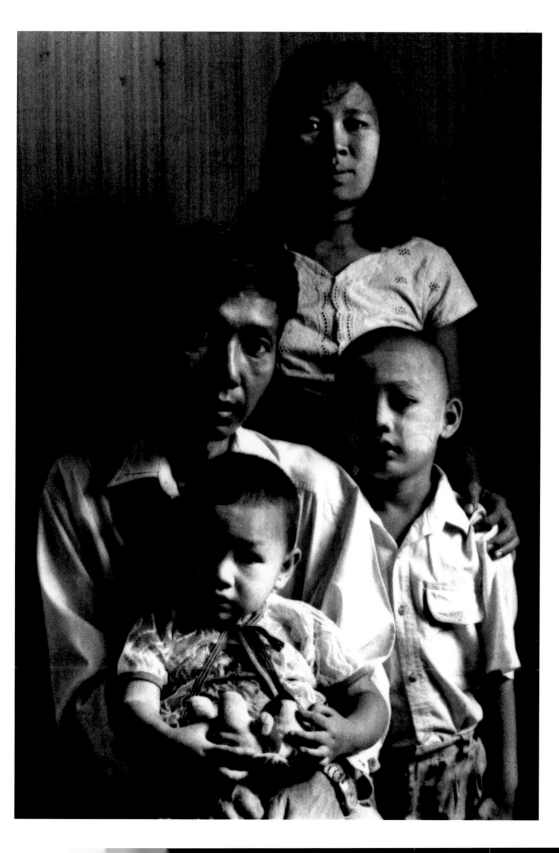

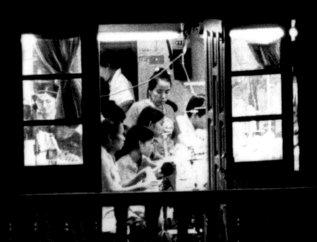

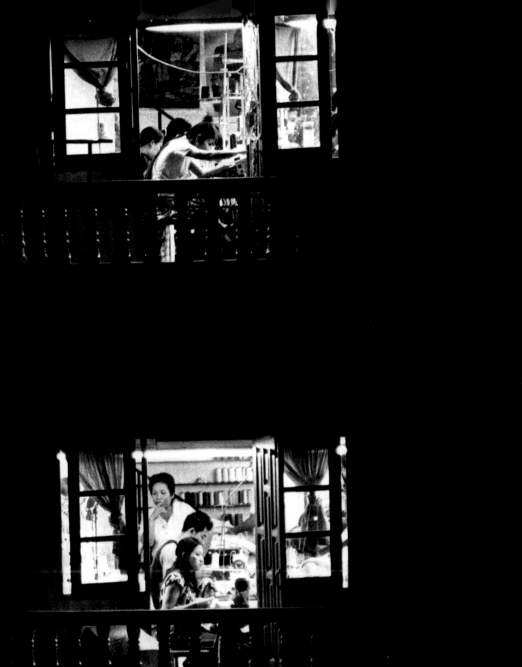

PREVIOUS SPREADS A sweatshop in the Thai border
town of Mae Sot. In Thailand, there are believed to
be at least two million migrant workers from Burma.

A Burmese brothel on the Chinese side near the
border town of Jie Gao, Yunnan.

ABOVE Methamphetamines from Wa-controlled
territory in Burma. In recent years, there has been
a flood of methamphetamines entering Thailand,
involving both the Burmese military and its ally,
the United Wa State Army.

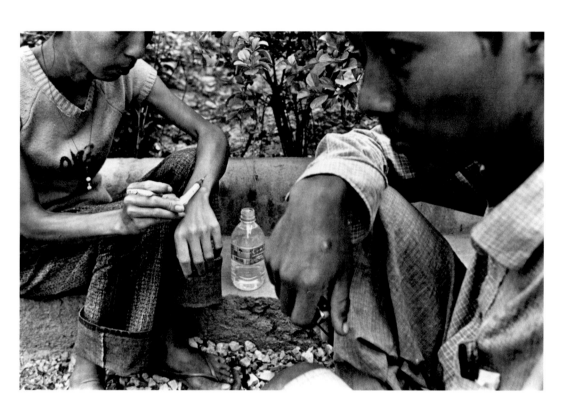

A couple from Burma shoot up in a backstreet of the
border town of Ruili in China. Migrant workers from
Burma fall easy prey to drugs in the twilight zones
of its various borders. Drugs are cheap and easily
available and provide many with an escape from the
hardships they face. In some cases, amphetamines are
dispensed to labourers to enable them to work harder.

Mae Hong Son: A tourist shows what it is like on
the other end of the lens. Promoted as the picturesque
"Long Kneck Karen" by Thailand's tourist industry,
the Paduang are not, in fact, an indigenous Thai
minority. They come from Karenni State in Burma,
mostly as refugees from Burma's civil war. Here they
are kept as virtual prisoners in purpose-built camps,
generating hundreds of thousands of tourist dollars.
The women see little of this money. Instead, it fills the
pockets of corrupt Thai police and middlemen,
as well as Karenni insurgents.

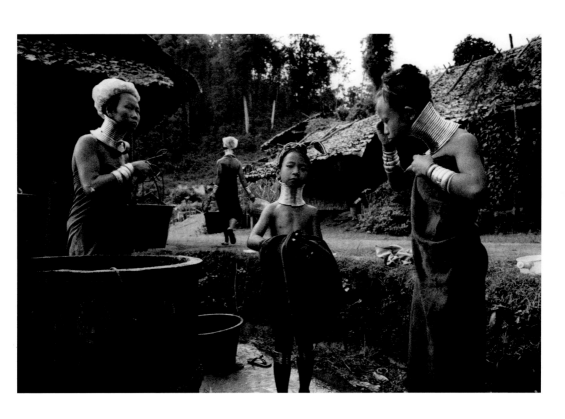

Thai-Burma border, Mae Hong Son. Padaung
women prepare for the first of the day's tourists.
Electricity is forbidden in the camps and the Padaung
have to make do with candlelight. The local Thai
businesswoman who looks after the camp said it is
more authentic this way. "Tourists don't like modern
things," she declared. "They want it to be natural."

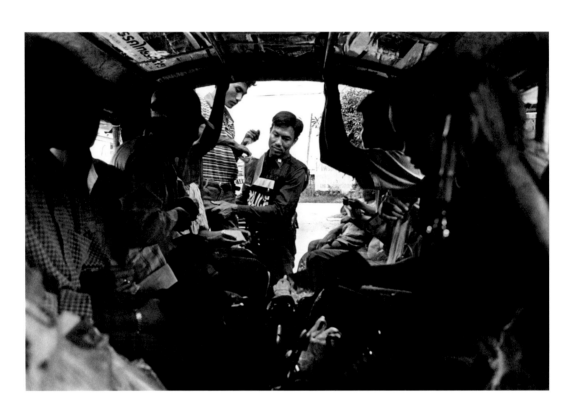

An unofficial police checkpoint in the Thai border
town of Mae Sot. Burmese who have come to Thailand
to buy goods or to seek work are regularly harassed
by the police. In this photograph, the policeman
checks the crotch of a Burmese man for drugs in
front of the women. Many Thai police are involved
in racketeering and extortion.

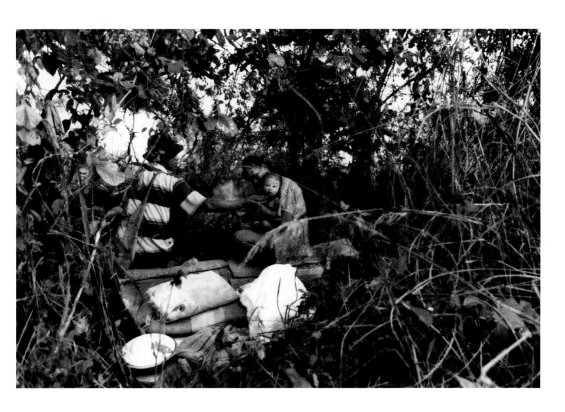

Too afraid to return to Burma, a migrant family hides
from the Thai police during a crackdown in October
1999. The month before, armed gunmen took over
the Burmese embassy in Bangkok. Taking 89 hostages,
they demanded that the junta honour the election of
1990, open a dialogue with pro-democracy politicians
and release all political prisoners, including Aung
San Suu Kyi. After 25 hours of intense negotiations
with Thai authorities, they released the hostages
unarmed. The gunmen were then flown to jungle
on the Burmese border and permitted to flee. Burma
then closed its border with Thailand. In response, the
authorities in Thailand rounded up tens of thousands
of Burmese workers and sent them back.

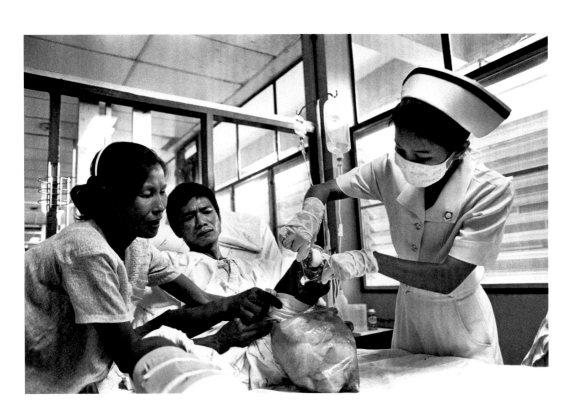

Khun Narumon, a Thai nurse in Mae Sot hospital
treats a farmer from Burma's Karen state who lost
his leg to a landmine. Landmines are used by all
sides in the conflict.

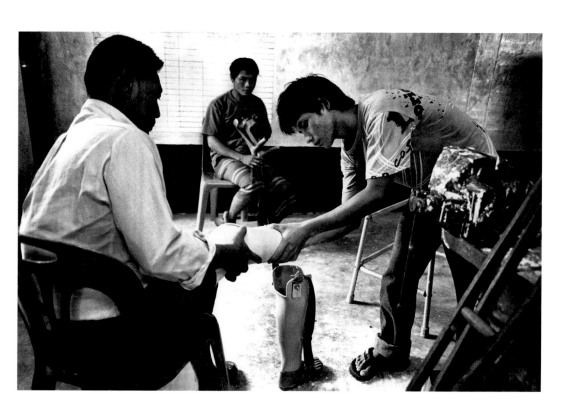

Amputees are fitted with limbs in Mae Tao clinic
on the Thai-Burma border.

U Ko Oo, a former member of the Tatmadaw, lost his leg to a landmine in 1990. He now lives rough in the border town of Mae Sot in Thailand.

OVERLEAF U Ko Oo survived on donations of food and money. "A lot of people feel pity towards me here," he said. "But I've never been discriminated against." He left Burma, he said, to escape poverty. He described widespread discrimination towards beggars and the homeless. "In Burma, people don't like the handicapped." Because of his disability, he couldn't get work. He sleeps rough in front of a house in Mae Sot that belongs to a Thai policeman and his Burmese wife, who took pity on him. "I've never been harrassed by the police," he said. "Sometimes they even give me pocket money."

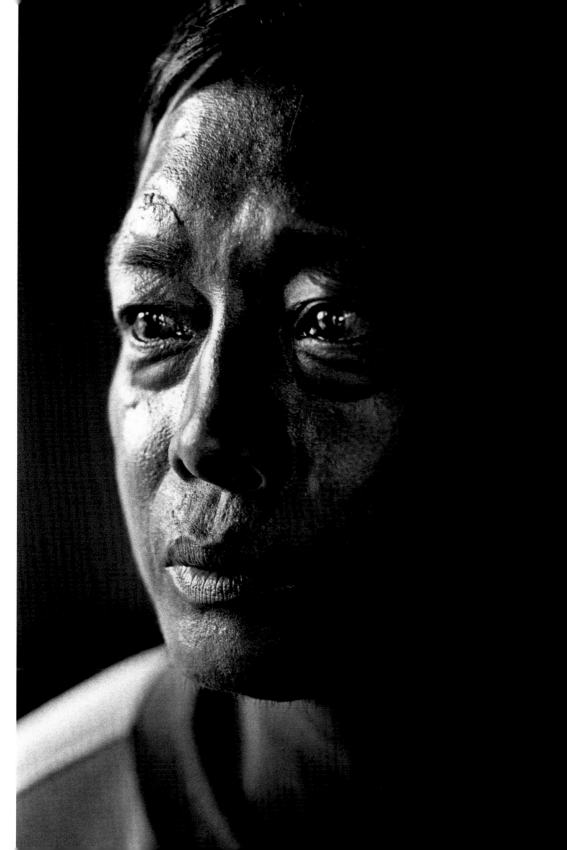

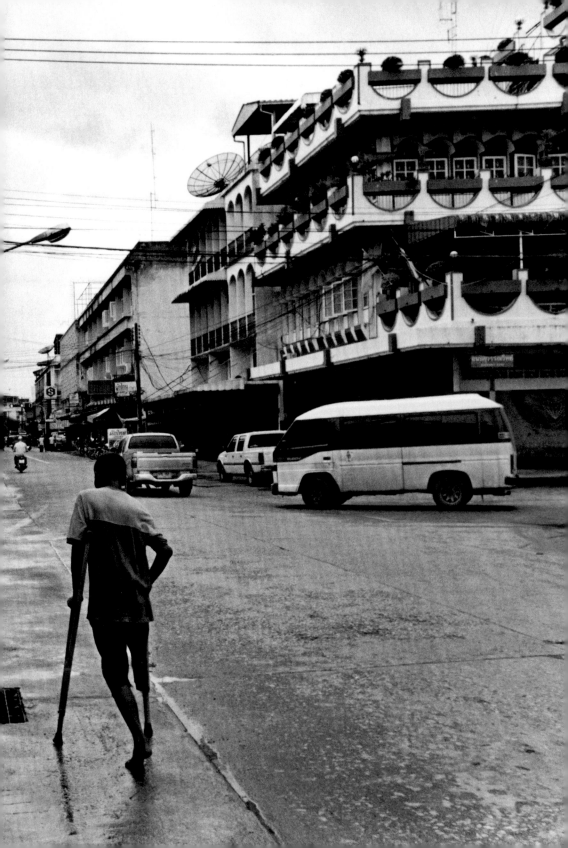

တပ်နှင့်ပြည်သူ

မဲကြည်ဖြူ

သွေးခွဲလာသူ

တို့ရန်သူ။

TATMADAW AND THE PEOPLE

JOIN IN ETERNAL UNITY

ANYONE ATTEMPTING TO DIVIDE

THEM OUR ENEMY

BRAVE
NEW BURMA

Who controls the past controls the future. Who controls the present controls the past.
 George Orwell, '1984'

For the first time in decades, change has come to Burma. But change brings new dangers and chief among them is the erasing of history and the invention of a "new" Burma in appearance alone. As Milan Kundera wrote, "The first step in liquidating a people is to erase its memory. Destroy its books, manufacture its culture, invent a new history. Before long, the nation will begin to forget what it is and what it was. The world around it will forget even faster."

In 2010, elections were held. Despite being widely dismissed as a sham in the international media, a new government was formed and Aung San Suu Kyi was released. The president, a former general called Thein Sein, embarked on what he described as an "irreversible" road to reform. These sweeping reforms included amnesties for hundreds of political prisoners, new labour laws, the relaxation

of press censorship and the admittance of Aung San Suu Kyi and her party, the National League for Democracy, into mainstream politics. In 2012, Suu Kyi was sworn into the new parliament.

Suu Kyi then made her first trip to Europe in 24 years. She received her Nobel Peace Prize in Oslo and addressed both Houses of Parliament in London. Later she went on to visit the United States and was awarded the US Congressional Gold Medal, meeting President Obama and a host of other politicians and public figures.

Meanwhile, the civil war continued. The previous year, in the north, a 17-year-old ceasefire between the Kachin Independence Organisation and the Burmese military broke down. In the ensuing violence, 75,000 people fled their homes. It was a pattern that had befallen ceasefire agreements many times before in other parts of the country, where underlying grievances remained unaddressed. Just before Suu Kyi left for Europe, sectarian violence erupted in Rahkine state between Muslim Rohingya and the Buddhist Rahkine. Tens

Aung San Suu Kyi at the Bodleian Library in Oxford after receiving her honorary degree. Feted abroad by celebrities and politicians, she has been described by Amnesty International as a "human rights superstar".

of thousands of people were displaced and military rule was reimposed in the area. During her trips abroad, Suu Kyi said almost nothing about the civil war or ethnic violence in Burma.

Burma is still controlled by the army. It is the dominant power in the country and its largest employer. When President Thein Sein ordered a halt to the fighting in Kachin state, the army's commanders ignored him, raising questions about how much real power Thein Sein has over the military.

Some people believe the reason Aung San Suu Kyi hasn't addressed the civil war, or the violence in Rakhine state, is because she is playing a delicate balancing act, careful not to push the army too hard lest they take control again. But having championed the cause of human rights for years, her continued silence has drawn criticism.

With Suu Kyi and members of her party being admitted into the political mainstream, there is a danger that many of the ethnic minorities will see this

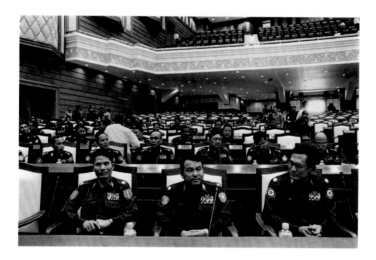

as further evidence of Burman dominance of the political landscape. Her presence in parliament legitimises a system created by a regime that not only kept her under house arrest for 15 years, but also tried to assassinate her.

She once spoke of her attachment to the Burmese army. "Not only was it built up by my father," she wrote, "as a child I was cared for by his soldiers." And although her father is revered by many inside Burma today, this reverence is far from universal. Parliament remains dominated by the military and its allies, who hold the vast majority of seats. Coupled with the deep-seated antipathy between ethnic minorities and the Burman majority, Suu Kyi's silence on the issue reinforces a suspicion that the new government has been formed by an "elite pact".

When she was sworn into Burma's new parliament in April 2012, she made the transition from a figure of principle to a politician. But now she is faced with making choices between the ideals that earned her the elevated position she is vaunted for and the business of affecting real change. Without a determined

and sustained effort to resolve civil and ethnic conflict, a lasting solution to Burma's crisis is unlikely to emerge. But it is also unrealistic to place the burden of solution on the shoulders of a single politician. Her status has brought with it impossibly high expectations. As she told UK parliamentarians in 2012, "This is the most important time for Burma... the moment of our greatest need."

The pace of change in Burma continues at a dizzying rate. Many investors, keen to exploit the new situation, are rushing in. Burma, strategically placed between India and China, is viewed as a final frontier for business, a cheap labour pool and a country rich with natural resources. The danger is that the cause of human and democratic rights will be sidelined, or ignored, as the West re-engages with Burma in pursuit of its own economic and strategic interests. But the problems that have plagued ordinary people under military rule – poverty, forced labour, land grabs, harassment and intimidation – continue. Ironically, the years of military rule have made the country vulnerable to exactly the kind of exploitation the army once used to justify their hold on power.

By November 2012, rising anti-Rohingya sentiment in the west of the country saw thousands of homes torched and more than 100,000 people forced from their homes. The civil war in the north has reached a stalemate. The continuing violence plays into the military's belief of unity by force.

For now, the army has withdrawn from direct rule, but the generals are still there, watching. They remain a law unto themselves.

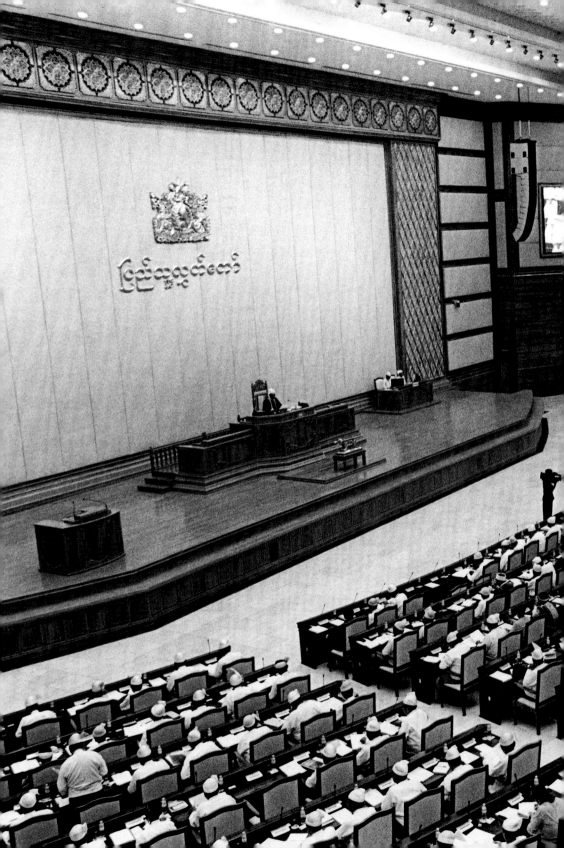

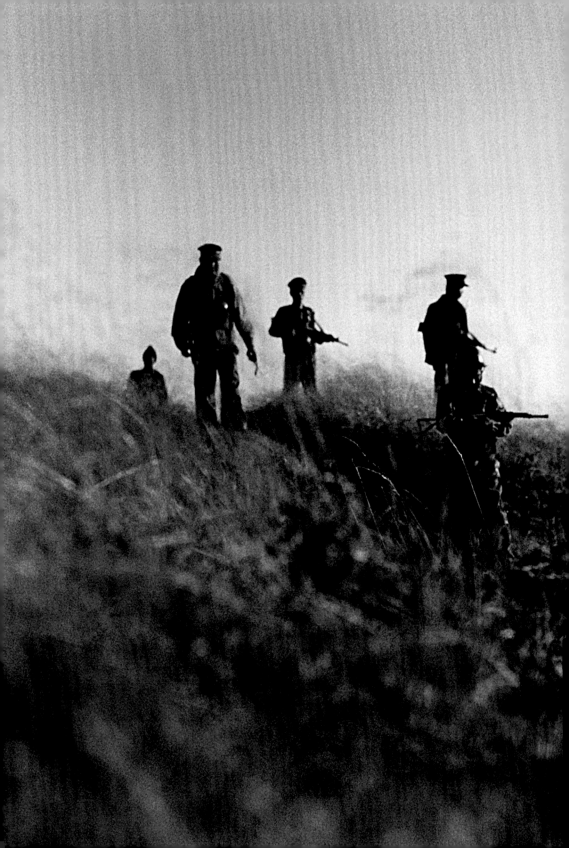

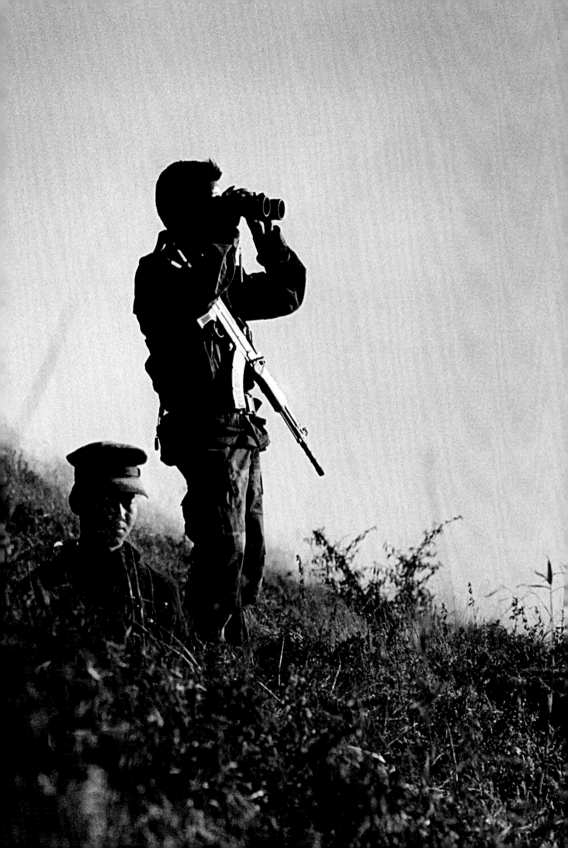

PREVIOUS SPREAD No end in sight. Kachin soldiers at Bum Sen outpost, Kachin state, 2012.

The chapter openers are taken directly from billboards erected in different parts of the country during the military dictactorship.

Nic Dunlop is a Bangkok-based photographer and writer represented by Panos Pictures in London. His work has been published worldwide. He is also author of *The Lost Executioner*, which tells the story of his discovery of Pol Pot's chief executioner, Comrade Duch. Nic received an award from the John Hopkins University for Excellence in International Journalism for his work on Duch's story. *Burma Soldier*, an HBO film co-directed by Nic, was awarded the Grand Jury Prize at the United Nations Association Film Festival in 2011, and nominated for an Emmy for Outstanding Individual Achievement in Writing.

www.nicdunlop.com
www.panos.co.uk

ACKNOWLEDGEMENTS

In a project that spans two decades, it would be impossible to list all the people who have assisted. I owe a deep debt of thanks to those in Burma who helpd at such personal risk to themselves and to their families. Because of the uncertain political situation they cannot be named and, out of respect to them, I would like to extend a general thanks to all the other friends and colleagues who have helped along the way, and to all the organisations who provided financial support for the project, (many of whom requested not to be named). I alone am responsible for any innaccuracies.

Some of the names of the people in this book have been changed in order to protect them.

FURTHER READING

Secret Histories, Emma Larkin. John Murray 2004
Everything is Broken, Emma Larkin. Granta 2010
The Trouser People, Andrew Marshall. River Books 2012
From the Land of Green Ghosts, A Burmese Odyssey,
 Pascal Khoo Thwe. Harper Collins 2002
Letters from Burma, Aung San Suu Kyi. Penguin 1996
Freedom from Fear, Aung San Suu Kyi. Penguin, 1991
Making Enemies, War and State Building in Burma,
 Mary P. Callahan. Cornell University 2004
Living Silence, Burma under Military Rule,
 Christina Fink. Zed Press 2001
Outrage, Burma's Struggle for Democracy,
 By Bertil Lintner. White Lotus 1990
Burma in Revolt, Opium and Insurgency Since 1948,
 By Bertil Lintner. White Lotus 1994
*Land of Jade, A Journey from India through Northern
 Burma to China*, Bertil Lintner. White Orchid 1996
Burma's Armed Forces, Power without Glory,
 Andrew Selth. East Bridge 2002
Burma and Japan Since 1940, Donald M. Seekins.
 Nordic Institute of Asian Studies
The Disorder in Order, The Army State in Burma since 1962,
 Donald M. Seekins. White Lotus 2002
The Political Legacy of Aung San, Josef Silverstein.
 Cornell Southeast Asia Program 1993
Burma: Insurgency and the Politics of Ethnicity,
 Martin Smith. Minority Rights Group 2002
The River of Lost Footsteps, Thant Myint-U.
 Faber and Faber 2006
Perfect Hostage, A Life of Aung San Suu Kyi,
 Justin Wintle. Hutchinson 2007
Mental Culture in Burmese Crisis Politics,
 Gustaaf Houtman. Tokyo University of Foreign
 Studies, 1999
Trouble in the Triangle, Opium and Conflict in Burma,
 edited by Martin Jelsma, Tom Kramer and
 Pietje Vervest. Silkworm Books, 2005
Forgotten Armies: Britain's Asian Empire & War with Japan,
 By Christopher Bayly and Tim Harper.
 Penguin 2004
Forgotten Wars, The End of Britian's Asian Empire,
 Christopher Bayly and Tim Harper. Penguin, 2008